IMAGES
of America

BISBEE

To three unique women who know that being "close" has nothing to do with miles. Teresa, Carmen, Mona—thank you. Now, go forth and make your own history!

ON THE COVER: An early Bisbee, Arizona, is shown with the copper smelter and its smokestacks in the background. (Courtesy of the Bisbee Mining & Historical Museum.)

IMAGES
of America

BISBEE

Ethel Jackson Price

ARCADIA
PUBLISHING

Copyright © 2004 by Ethel Jackson Price
ISBN 978-0-7385-2894-6

Published by Arcadia Publishing
Charleston, South Carolina

Printed in the United States of America

Library of Congress Catalog Card Number: 2004104608

For all general information contact Arcadia Publishing at:
Telephone 843-853-2070
Fax 843-853-0044
E-mail sales@arcadiapublishing.com
For customer service and orders:
Toll-Free 1-888-313-2665

Visit us on the Internet at www.arcadiapublishing.com

CONTENTS

ACKNOWLEDGMENTS

Working on this book—sometimes at 4 a.m. when the muse visits—has been quite an experience and I've met some great (and very helpful) caretakers of history. These are people that I now call friends. I've learned so much from them! (And as Jim Kempert, editor of my first book, once told me, "History never sleeps." He was right.)

Yes, I've come to understand more and more the intrinsic value of stories and images from our past. A collection, such as the one in this book, shows us our heritage and from such a collection, we learn more of who we are.

It would take an entire chapter to name everyone who helped with this collection; however, some of the major participants, in no special order, are Mary and John Magoffin (and Mary Burnett) of the Cochise County Historical Society in Douglas; Ruth and Richard Cooksley of the Bisbee Restoration Museum in Bisbee; Carrie Gustafson, Boyd Nicholl, and Anna Garcia of the Bisbee Mining & Historical Museum in Bisbee; and Neil Bush, of Las Vegas, who provided numerous antique postcards from his personal collection.

Mary, Mary, John, Ruth, Richard, Carrie, Boyd, Anna, and Neil are some very special caretakers of Bisbee history. People like me need people like them.

And we need others. I'm merely the "middle-man" between the true caretakers of history and Arcadia Publishing—particularly, Christine Talbot (my very patient editor) and David Mandel, who wrote the copy on the back cover.

To all of you—my everlasting appreciation (here, you should visualize a deep curtsey); I couldn't have done it without you.

INTRODUCTION

Bisbee, Arizona, is—at an official altitude of 5,520 feet (5,300 feet in some places)—often called "the *other* mile-high city." It is also a strangely unique survivor.

It all began with the accidental discovery of cerussite, a natural lead carbonate whose presence indicates that copper or silver may exist nearby. How had Coronado missed it during his noisy exploration of the area, a cumbersome event involving more than 1,000 people and 1,500 head of livestock? Did he expect shiny, refined minerals to be lying around waiting for him? Did he understand what he was looking for?

In spite of (or because of) his bumbling expedition, the treasure stayed hidden for more than 300 years after Coronado passed by. The rugged Mule Mountains quietly protected their secret, permitting only the occasional flash of a very fleeting smile to tease an adventurer.

One thing is certain. Until the late 1870s, few white men ventured into the Mules; of the bravely independent (or foolhardy) souls who heeded their Lorelei, most were never seen again. They simply disappeared. How many? Why? What happened to them? No one knows. Stories were told, of course, stories of what to expect if captured by the Apaches. It would be, "they" said, an incredibly agonizing fate, ending in termination long after one wished for it. Soon, a darkly forbidding mystique took hold, a growing mystique surrounding the sharp peaks and craggy gulches that formed the Mules.

A new army post called Camp (later, Fort) Huachuca had been established in March of 1877, but it was 28 miles to the west. The young fort's assigned purpose was to protect both the Santa Cruz and the San Pedro Valleys. Nothing was said of the Mule Mountains. So on an unusually hot day in May 1877—ten years before an earthquake devastated what is now southeast Arizona—a group of 15 brave men set out from Fort Bowie. Only 15—not the unwieldy group that formed the Coronado expedition!

Why did they do it? Because several Apaches had escaped the prison-like fixed boundaries of the hated reservation where they'd been sent and—political borders meaning nothing to them—were reportedly on the way to Mexico. The Mule Mountains, with their steep canyons and heavy thickets, would be a good place for the escapees to try eluding capture.

Lt. John Anthony Rucker and his scout, Jack Dunn, were made of sturdier stuff than most. Under a hot sun, the 15 sweating men (dressed mostly in wool uniforms) and their strong mounts crossed the Sulphur Springs Valley. After unsatisfactory stops at a spring or two, they found themselves in the cooler Mule Mountains where they searched inch by seeming inch for signs of recent passersby. The tiniest thing would serve—a small broken twig, a bruised blade of grass, a scratched rock. It was meticulous work.

In late afternoon, the men decided to make camp and resume scouting the next day. Dunn went in search of potable water. He found it near the base of what is now Castle Rock and filled several canteens to take back. Along the way, the sharp-eyed scout unexpectedly found signs of mineral deposits; upon his return, he duly reported his findings. Camp was quickly broken and moved to the springs at Castle Rock.

Rucker and Dunn wisely kept their counsel. The area was still part of Pima County (Cochise County didn't exist until 1881) so the men had to wait until they could visit Tucson to file a claim, full knowing that once word got out, others would come. It did, and eventually the whole of Bisbee would evolve.

The strangely unique community of Bisbee would be built on—and sometimes into—the mountainsides, on land that has at one time or another been part of Mexico, part of the Territory of New Mexico, part of the Confederate States of America, and part of the Territory of Arizona. It survived Indian wars, rampaging fires, devastating floods, and a dark day in history known as 'the Deportation.' Its major focus would change from the wild-and-wooly pre-statehood days of mining (with a Brewery Gulch 'tenderloin district' rivaling San Francisco's) to that of a more colorful 1960s-ish art colony, settling finally in being today's tourist destination.

Bisbee is actually a string of communities joined together by roadways, politics, and industry. Once, there were communities called Bakerville, Briggs, Cochise, Don Luis, Galena, Huachuca Terrace, Jiggerville, Johnson Addition, Lowell, Ragtown, Saginaw, South Bisbee, Tintown, Third Addition, Upper Lowell, Warren, and Winwood Addition. A few still exist where they started but, on paper, they're all Bisbee. Some were simply absorbed by the mines and no longer exist. Others were literally moved—lock, stock, and barrel—to make way for the industry's behemoth equipment, roadways, and land needed for open-pit mines

Unfortunately, most visitors of today see only Old Bisbee (aka: downtown). Some travel a short distance from downtown to see the Lavender Pit—and no, Lavender is not a color—without knowing they'll see the Sacramento Pit first. Some go on to visit the Warren District or Lowell; fewer continue into Tintown, San Jose, and other parts of Bisbee.

Now, it's time to fully explore it all, from the Continental Divide marker atop Mule Mountain, from the long tunnel at the city's front door, to the southernmost tip of the Rocky Mountains outside its back door; it's time to learn hidden secrets of a former rip-snorting mining city that's settled into being the grand lady called Bisbee, Queen of the Copper Camps.

Come with me . . .

One

THE TURN OF
THE 20TH CENTURY

Early ancestors of the Apache may have walked across a land-bridge that once connected Russia to Alaska. From Alaska, the people migrated south, some to lands that eventually became Arizona. Along the way, groups increased in size; some branched out, with each branch becoming a clan-type unit. Thus, the Apache Nation found itself with branches named for the home location of each: Warm Springs, Chiricahuas, etc. (There were also sub-groups within the sub-groups.)

The land where Bisbee now exists was once part of the Chiricahua's home territory. When the Spanish explorers came, the land was taken from the people. The Apache were imprisoned on reservations. Some broke loose but were pursued by the Army. Their anticipated escape route led to the discovery of copper—and the creation of Bisbee.

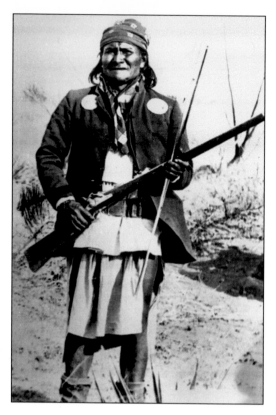

One of the most famous of Apaches was born in 1823 and named Goyahkla (it translates as "One Who Yawns"). The name he'd come to be called, Geronimo, was given to him by the Spaniards. Legends have two faces, and stories about Geronimo are both extraordinarily good and incredibly bad (depending on one's point of view.) (Courtesy of Bisbee Mining & Historical Museum.)

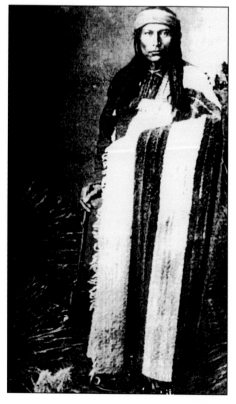

Naiche—sometimes known as "Natchez," a name given him by the Spaniards—was the second son of Cochise and became the last chief of the Chiricahuas after his older brother was killed. Suddenly thrust into the position of chief, a young and handsome Naiche was mentored by the charismatic but bitterly defiant warrior called Geronimo. (Courtesy of Fort Huachuca Historical Museum.)

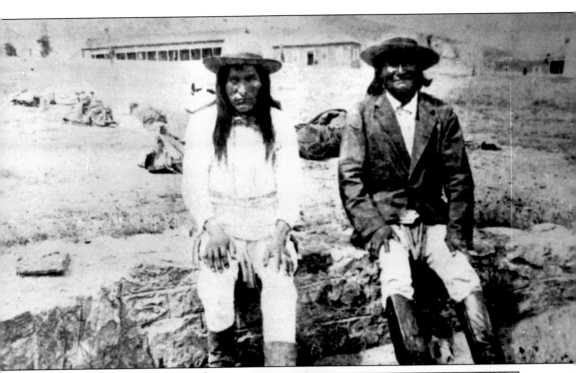

Overcome by the sheer numbers of invading "White Eyes" and their advanced technology, Chiricahuas were forcibly relocated and kept under guard. Here, Geronimo is seated on the right, Naiche on the left. Note the expressions on their faces. (Courtesy of Bisbee Mining & Historical Museum.)

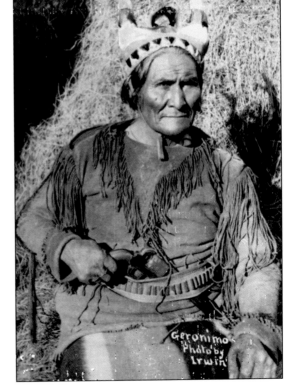

Geronimo would, after his final surrender, become quite a showman, often appearing for the benefit of visiting photographers. The celebrated warrior's life bridged two centuries, from his birth in 1823 to death in 1909. (Courtesy of Bisbee Mining & Historical Museum.)

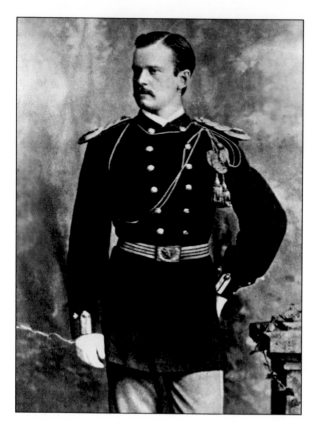

Lt. John A. Rucker led an expedition of 15 men from Fort Bowie on May 9, 1877, to recapture escaped renegades. The Indians would, the Army thought, try to elude their pursuers in the rugged Mule Mountains; that's where they'd search for faint signs of recent passage. (Courtesy of Bisbee Mining & Historical Museum.)

After making camp in the Mules, George Dunn (Rucker's scout) went looking for potable water. He found it. He also found signs that copper was nearby. After reporting to Rucker, the men filed a claim; not long after, Rucker died trying to rescue one of his men from drowning. Dunn would be joined by his wife, Mary, and they'd go on to live a good life. (Courtesy of Bisbee Mining & Historical Museum.)

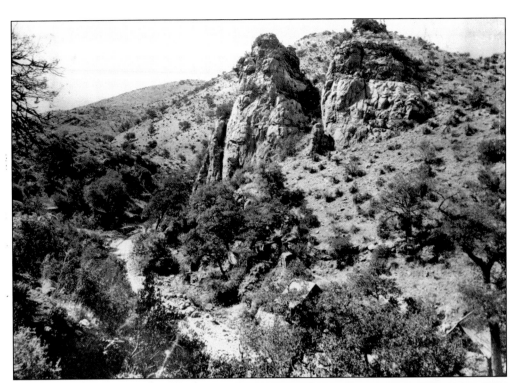

Rucker and Dunn were right. Word of the strike traveled fast and men rushed to file claims. By 1883, there was a cabin at Castle Rock. It was built by the infamous George Warren, a colorful alcoholic who'd one day have the entire mining district and part of the city named for him. (Courtesy of Bisbee Mining & Historical Museum.)

It's been said that a young George Warren was captured and enslaved by Apaches, then traded for a sack of sugar. He once bet everything on a race in which he ran against a horse. Declared insane, placed in an asylum, "cured," indentured to a Mexican, and rescued, he died on a bitterly cold February day, at the age of either 43 or 44 (depending on which records are checked). He now lies buried in Evergreen Cemetery. (Courtesy of Bisbee Mining & Historical Museum.)

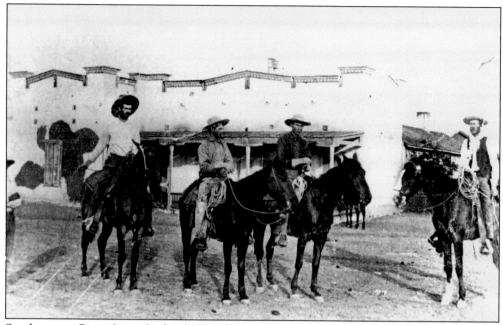

Southeastern Pima (now Cochise) County was devoted not just to mining; cattle ranches provided food for the miners, the settlers. In 1883, one such ranch was the Chiricahua Cattle Company; these four cowboys worked for the CCC, along with the Chinese cook standing nearby. (Courtesy of Cochise County Historical Society.)

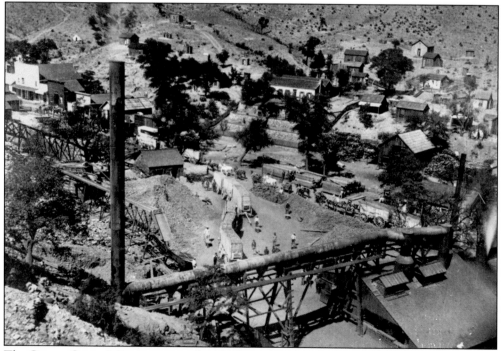

The Copper Queen Mine transported its product in ore wagons, shown here as they make their way to the Copper Queen Smelter. That's the smelter's smokestack in the foreground. (Courtesy of Bisbee Mining & Historical Museum.)

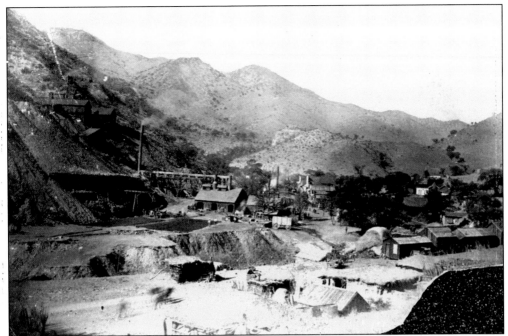

Located near Main Street in Bisbee, the Copper Queen Smelter wasn't all that distant(by today's standards) from the mines. The smokestack seen here is the same one that appears more prominently in the immediately preceding photo. (Courtesy of Bisbee Mining & Historical Museum.)

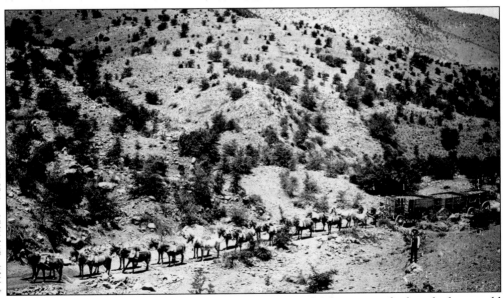

Proximity (by today's standards) didn't mean it was easy. Mule trains, of a length that would put the famed "20-mule teams" to shame, often hauled ore wagons up and over the Continental Divide. Yes, brakes sometimes failed, and an ore wagon would go over the side of the mountain trail, dragging the mules with it. The team in this photo is lucky; it made it. (Courtesy of Bisbee Mining & Historical Museum.)

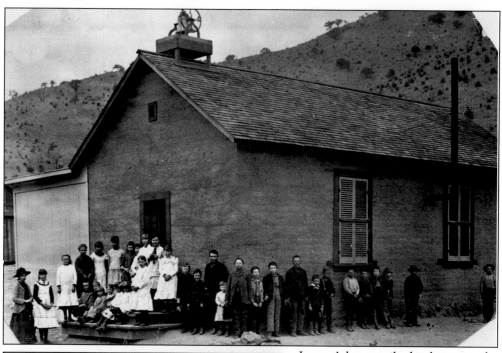

It wasn't long until schools appeared. This small school, shown in 1884, was built on the identical site where Central School would later stand. It was the second school in Bisbee and its teacher was Daisy Robinson. (Courtesy of Bisbee Mining & Historical Museum.)

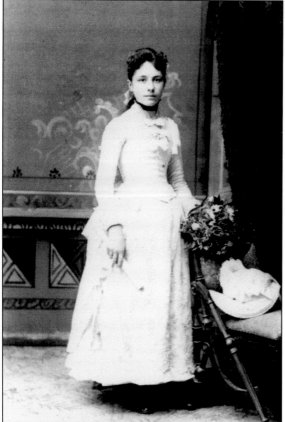

This very fortunate (but unidentified) young woman was encouraged to pursue an education . . . somewhat unusual in those days. She stands, holding her diploma, dressed inthe height of fashion with long sleeves, high neck, and—oh my!—her ankles are showing! A matching hat rests on the chair beside her. (Courtesy of Cochise County Historical Society.)

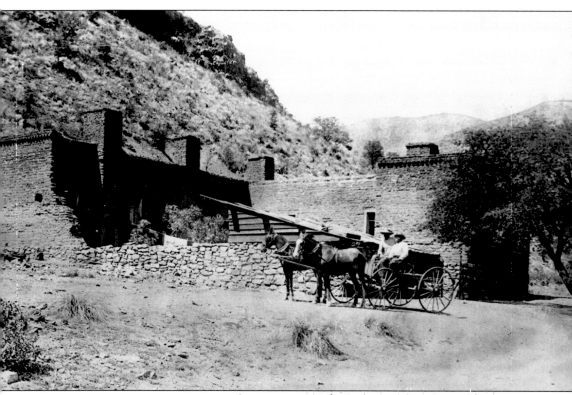

This was often called "the Castle" and was built by Col. William Herring for the Neptune Mining Company. Because the Copper Queen used most of the running water in Mule Canyon, the Neptune built its smelter a few miles away, on the San Pedro River at what would become Hereford (not where Hereford is today, but where it began). However, the Herrings did not live in Hereford. "The Castle" was built in Mule Canyon to serve as living quarters for the Herring family and as company offices. Unfortunately, the Neptune strike did not live up to its promise. When it fizzled, financial problems—exacerbated, in part, by the cost of building and maintaining this facility—mounted. Eventually, the Herrings vacated and the Castle was sold at a sheriff's auction; a decade later, it was absorbed into the Copper Queen Mining Company. (Courtesy of Bisbee Mining & Historical Museum.)

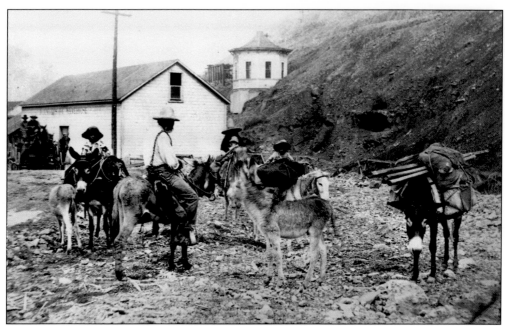

Not every resident was "well to do" in an early and segregated Bisbee; these poor Mexicans lived in small, probably sub-standard, dwellings built on rocky hardscrabble earth, with mules and burros to carry whatever needed moving. (Courtesy of Bisbee Mining & Historical Museum.)

Doing laundry meant water was carried in from outside, and the chore usually sported two tubs—one for washing and one for rinsing. Homemade lye soap was probably used. This one was very modern, with a real washboard and a hand-cranked wringer. (Photo by Ron Price.)

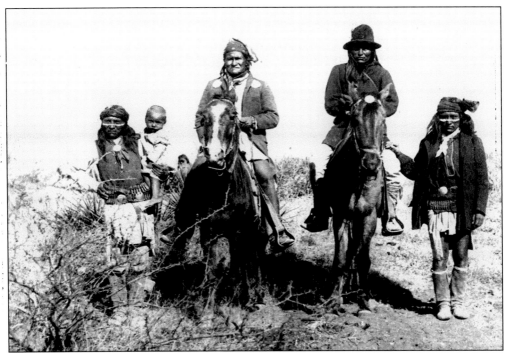

Outside the apparently safer havens of the town, unrest was still going on but slowing. Shown here, from left to right, are Perico (Geronimo's brother) with a child, Geronimo, Naiche, and Tsisnah, on their way to their first surrender in 1886. (Courtesy of Bisbee Mining & Historical Museum.)

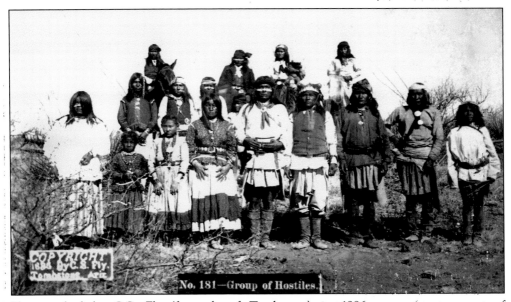

Photographed by C.S. Fly (famously of Tombstone) in 1886, an unhappy group of Apache family members have been rounded up and are awaiting their fate. As was common in those days, Fly referred to them as "Hostiles." (Courtesy of Bisbee Mining & Historical Museum.)

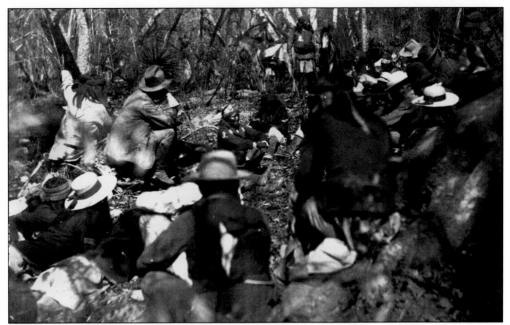

In late March 1886, Geronimo and some of his people negotiated with General George Crook; it would be one of four surrenders. At this one, a peddler snuck into camp where he sold whiskey to the Indians, stirring them up and, perhaps, causing the war to be prolonged. (Courtesy of Bisbee Mining & Historical Museum.)

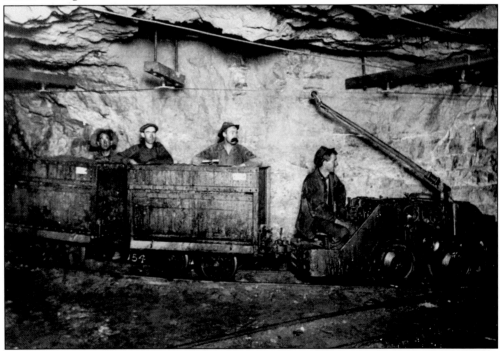

Whatever unrest existed, the mining industry grew quickly; by 1890, these Phelps-Dodge miners were riding ore cars down into the inside of the mountains. (Courtesy of Bisbee Mining & Historical Museum.)

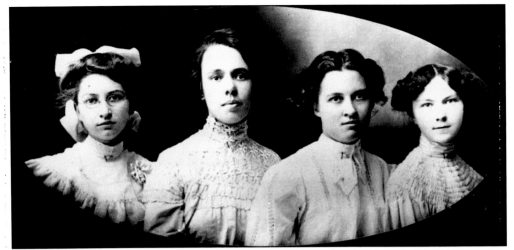

Bisbee was not without its respected society. From left to right, these ladies are Oma Westcott Brewster, Mary Stedley Stuart, Elsie Toles, and Edna Newman Thomas—all dressed in the height of modern fashion. (Courtesy of Bisbee Mining & Historical Museum.)

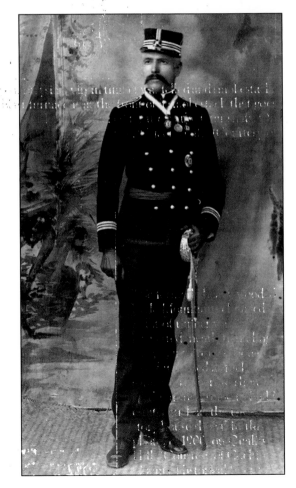

An officer and a gentleman— Col. Emilio Kosterlitz is dressed in his finest uniform, including a beautiful ceremonial sword with decorated silver handle. (Courtesy of Bisbee Mining & Historical Museum.)

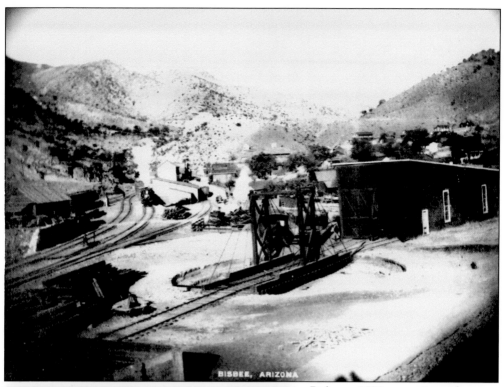

Bisbee c. 1890 was a city with an eclectic mix of people but only one real industry: mining. Yet thetown seemed to grow almost exponentially, with new trucks and buildings appearing daily. (Courtesy of Cochise County Historical Society.)

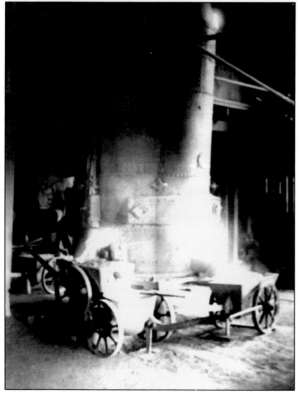

This is the interior of a hot, noisy, processing facility. The low ports are where the molten metal comes out; the high port is where slag is skimmed before being transported to one of the slag heaps still seen in parts of Bisbee. (Courtesy of Cochise County Historical Society.)

In the interior of a Bisbee smelter, c. 1891, a thimble-cart is by the furnace and a man working as a "skimmer" stands with a bar sometimes called a "picky poke." Behind the skimmer, on his left, is the boss. (Courtesy of Cochise County Historical Society.)

The smelter's powerhouse, c. 1891, was noisy! Steam engines provide the drive for a belt going to the drive shaft. That tall pipe on the right brings steam to the inlet valves and cams on the engines while balls provide a check on central engine speed. (Courtesy of Cochise County Historical Society.)

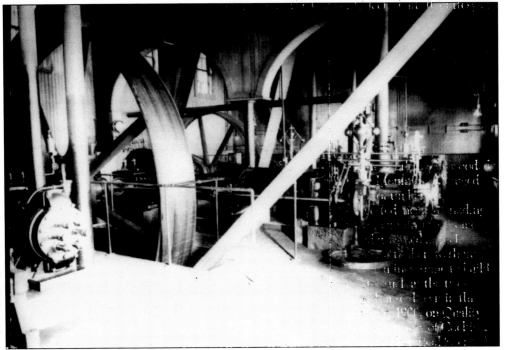

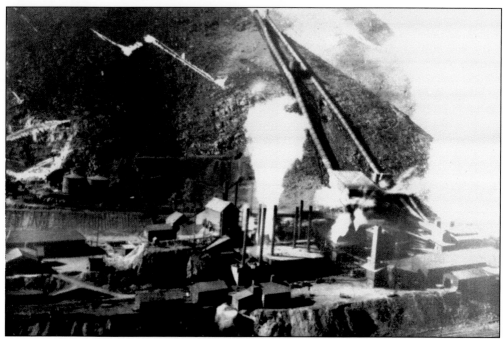

This smelter at Bisbee served the Czar Mine, c. 1898. The Czar was a relatively shallow orebody when compared to the Copper Queen and others nearby. Still, the Czar's shaft was dug east of the Copper Queen, just west of the original Rucker. (Courtesy of Cochise County Historical Society.)

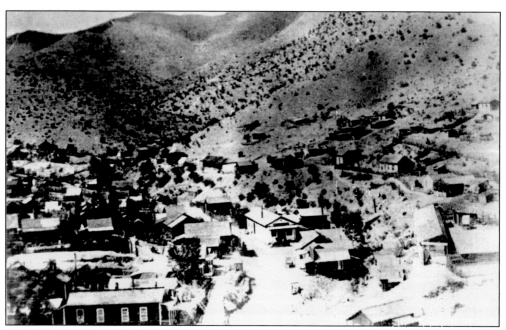

While behemoth equipment and strong, sweating men worked nearby, Bisbee grew. This is the infamous Brewery Gulch, c. 1895, looking north, where the cathouses, opium dens, bars, etc., were located. These businesses ran 24 hours a day. (Courtesy of Cochise County Historical Society.)

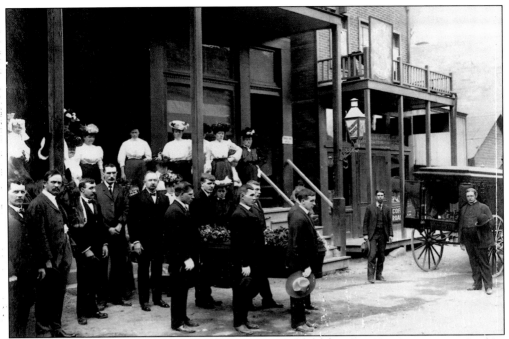

A well-attended funeral took place in Bisbee, c. 1898, arranged by Hubbard's Mortuary, but the names of the pallbearers and other attendees are lost to history. The lady in black, on the right at street level, was probably the widow; the lady in black on the veranda could have been the mother. (Courtesy of Bisbee Mining & Historical Museum.)

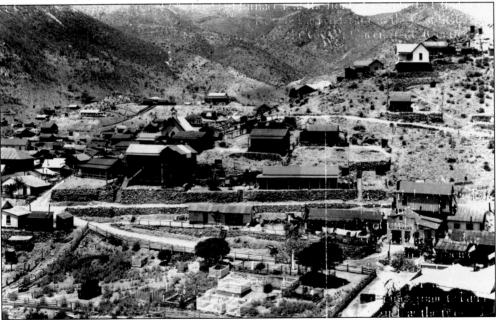

At the turn of the 20th century, the town had become quite populated. Here, one looks across Brewery Gulch and up Tombstone Canyon, c. 1900. That's the Old Cemetery in the foreground, Castle Rock is on the left, and Opera Drive runs across the center, bordered by a rock wall. (Courtesy of Bisbee Mining & Historical Museum.)

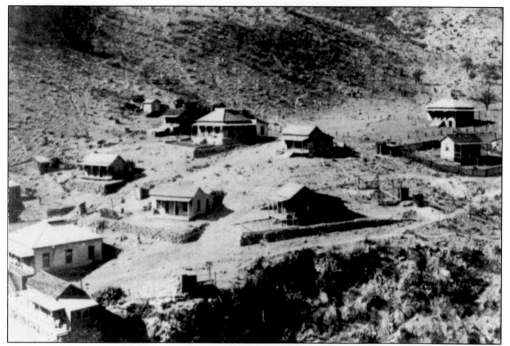

Quality Hill was established as an upscale community of fine homes intended for mining executives and their families. Though now quite congested, in 1900 (shown here) when Bisbee had a population of more than 6,000, Quality Hill was "the" place to live, open and spacious. (Courtesy Cochise County Historical Society.)

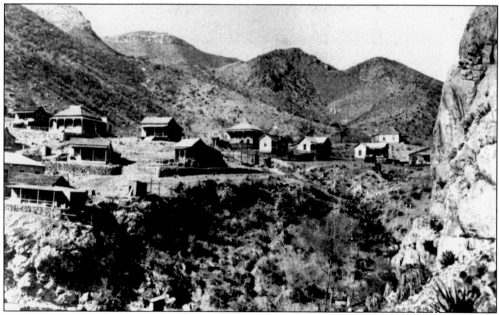

As 1900 wore on, the atmosphere on Quality Hill continued to be fresher and cleaner than downtown or other parts of town where breezes blew pollution from smelter smokestacks directly into neighborhoods. The community—true to its name—could probably be called the first "planned community." (Courtesy of Cochise County Historical Society.)

Two

BISBEE BURNING

In the early 1900s, Bisbee's population rapidly increased, reaching as many as 10,000. Construction demanded wood! With trees gone, the rocky mountainsides sent rainwater crashing down into the canyon. It happened every summer during monsoon season, sometimes more so than other years. An example is 1879 (or 1880), 1890, 1896, 1902, and the summer of 1908 (and/or "c. 1910," depending on the source). Each time, entire portions of Bisbee were washed away and each time, the community rebuilt.

If not floods, it was fire. Conflagrations were caused, in part, by a combination of "tinderbox" construction, congested placement, and the use of lanterns or candles (there was no electricity). The devastating fires occurred in February 1885, in June 1907, and just over a year later, on October 14, 1908, the granddaddy of them all destroyed three fourths of what was left from the fire a year earlier. Did it end there? No. On February 25, 1910, fire destroyed the rest of Bisbee's early downtown.

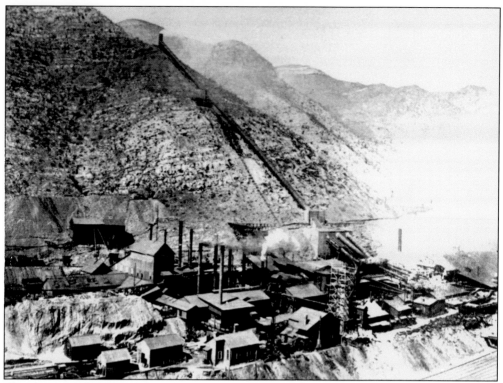

The mines greatly affected the surrounding countryside; virgin timber was felled and smokestacks belched smoke. In this photo, c. 1900, the blast furnace is at the front of a smokestack that goes uphill. The converter is in the center; timbers, far left, are stacked for use at the Czar shaft. On the far right, above the smokestacks, is the entrance to the Copper Queen shaft. (Courtesy of Cochise County Historical Society.)

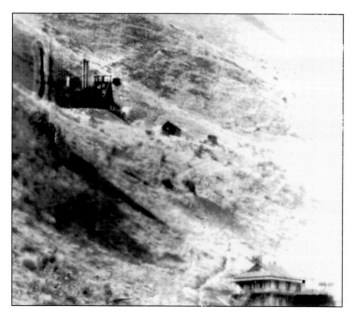

The formerly heavy-wooded Mule Mountains changed. A lot of timber was harvested, nearly denuding the mountainsides. Some wood was used as fuel, some for timbers to shore up the mines, some to build estates such as the two-story house shown in this photo, c. 1900, on Quality Hill. (Courtesy of Cochise County Historical Society.)

The Elks, one of the city's foremost benevolent associations, established themselves and on April 15, 1901 (income tax didn't yet exist, so the date isn't significant), they held a parade going down an unpaved Main Street. If one didn't walk, conveyance was still by horse-and-buggy. (Courtesy of Bisbee Mining & Historical Museum.)

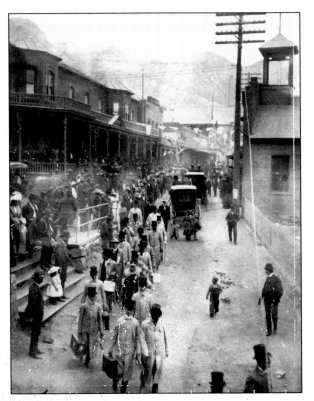

This is what it was like deep inside the Copper Queen Mine. On the back of this postcard, dated March 30, 1902, the sender wrote, "The whole town is mined under. The houses are built on steps going up the mountains." (Courtesy of Neil Bush.)

Where men gather to work, families soon follow; where there are families, churches are built. One of the more famous in Bisbee history is the Covenant Presbyterian Church, started in 1902 and completed in 1903. It was intended as a reproduction of a Dutch Reformed Church and remains just west of the Copper Queen Hotel. (Courtesy of Bisbee Mining & Historical Museum.)

Though most construction in 1903 was of wood, not everything was. Multi-story commercial buildings were often built from stone. Many were constructed in such a way that storm water could drain through without washing away the roads. This fitted-rock building is the former YMCA (later the Gym Club Apartments). (Courtesy of Bisbee Mining & Historical Museum.)

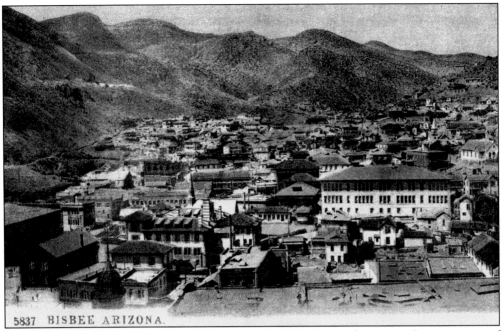

On the back of this postcard, dated November 19, 1905, the sender wrote, "Just a portion of our city. The business portion down in the canyon and the residences on the mountain sides." (Courtesy of Neil Bush.)

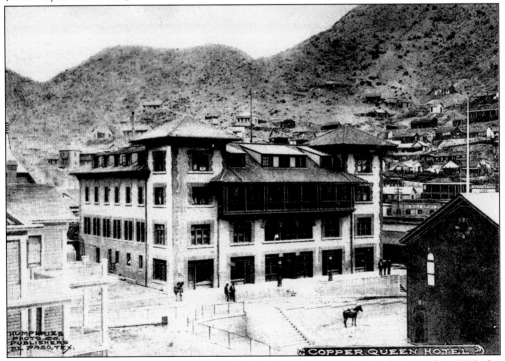

This is the lush Copper Queen Hotel. On the back of this postcard, dated November 1905, the sender wrote, "The only Hotel in the city, I live on the first floor next to the roof—and I had to get it at twenty per." (Courtesy of Neil Bush.)

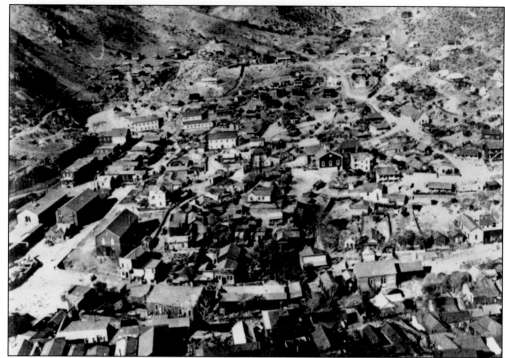

The actual business portion of Bisbee, the downtown, was built in the canyon. This view, c. 1905, looks west up Tombstone Canyon. That's the Copper Queen Store (a "companystore") with its warehouse and office buildings on the left. (Courtesy of Cochise County Historical Society.)

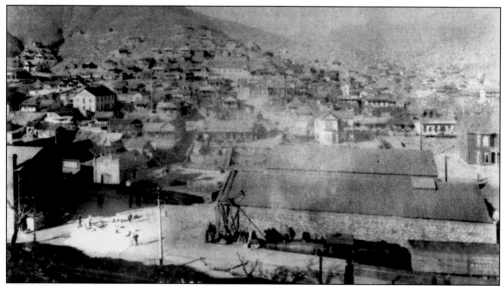

In this view, looking north, in 1905, the post office and library share the large building in the right foreground. The Copper Queen Store is closest to the train, and the Copper Queen Warehouse is close by. The Copper Queen office building is on the far left. A locomotive from the Arizona & Southeastern Railroad waits alongside one from the Atchison, Topeka & Santa Fe, called the AT&SF. (Courtesy of Cochise County Historical Society.)

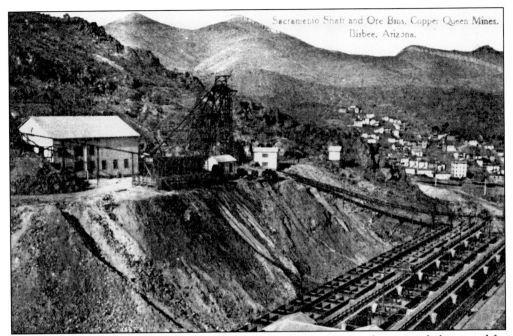

The Sacramento Shaft and ore bins are shown before the mountain disappeared, decimated for what was inside. The sender of this postcard, dated December 9, 1906, wrote on it, "One of the Copper Queen Mines, a rear view of a shaft, a sister mine to the one I work in and can walk from our shaft to another underground." (Courtesy of Neil Bush.)

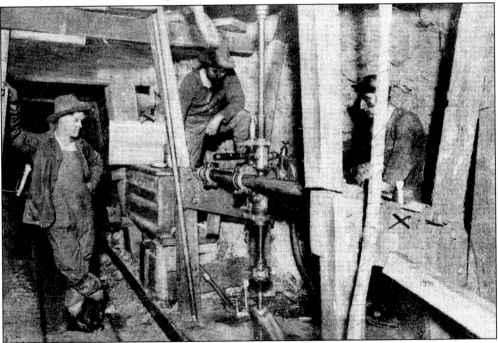

Diamond drills were used at the Calumet & Arizona (C&A) Mine. On this postcard, dated December 3, 1906, the sender wrote, "How'd you like to work with these fellows 1200 feet below? Notice candles which light up to work by." (Courtesy of Neil Bush.)

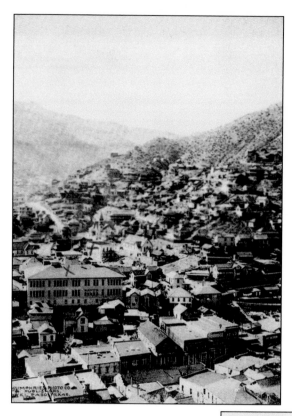

There was a population boom, although fire or flood would damage or destroy much of the town. However, on this postcard, dated 1906, the sender wrote, "Put X on the schoolhouse roof and just over to the right is always where I board again." (Courtesy of Neil Bush.)

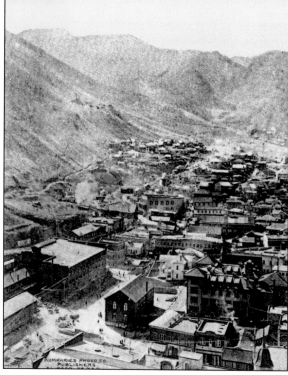

Chihuahua Hill, largely populated by the Spanish-speaking, was up Brewery Gulch. This view is from Chihuahua Hill, looking down to the main part of the city. On this postcard, dated January 23, 1906, the sender wrote, "This is an awfully hilly country. I don't think we will be here very long." (Courtesy of Neil Bush.)

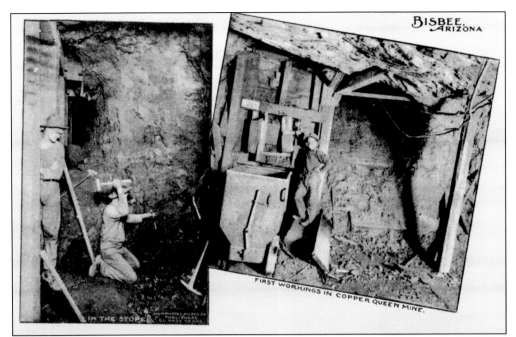

Shown here is a man working inside the mine (aka: the "stope") and a second view of the first workings in the Copper Queen Mine. On this postcard, dated August 26, 1906, the sender wrote, "Dear Father, how would you like to work in one of these mines? It is not like the Wagon Factory." (Courtesy of Neil Bush.)

At the YMCA in Bisbee, male guests could find an inexpensive (and clean) place to stay. The Central School was next door. On this postcard, dated September 3, 1906, the sender wrote, "Dear Mother, this is where I am and have been writing to you. It is a nice place. It is near the store and I come up here at noon time and have a good time." (Courtesy of Neil Bush.)

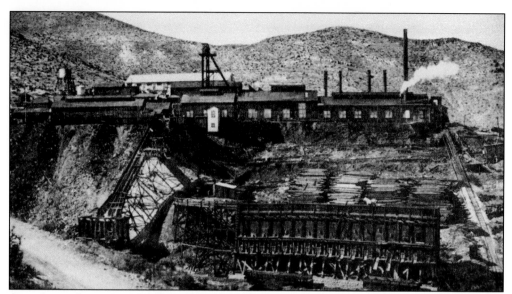

Outside, work continued. The Irish Mag Mine (named for a woman who worked in the "tenderloin" district) was developed by Calumet & Arizona, whose stockholders included a few with ties to U.S. Steel. On this card, dated December 9, 1906, the sender wrote, "Some 300 miles of track under ground in Bisbee for small cars that reach the elbows." (Courtesy of Neil Bush.)

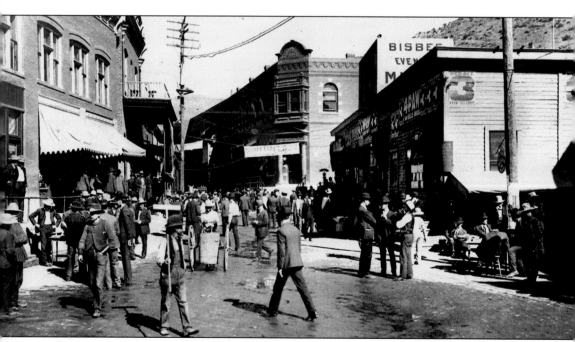

Despite previous fires and floods, the busyness of business continued in 1906, even at the lower end of Brewery Gulch where it joined Main Street. The brothels (one of which was the place of employment of a San Francisco preacher's daughter named Ethel), bars, and opium dens were further up Brewery Gulch—and stayed open 24 hours a day. (Courtesy of Bisbee Mining & Historical Museum.)

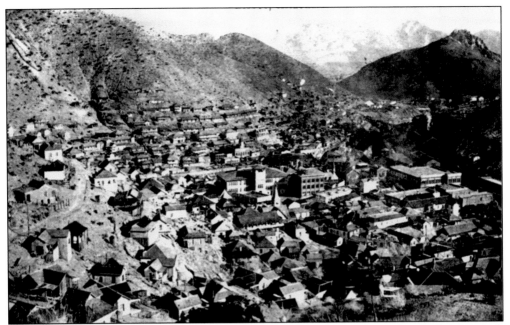

Homes had, for some time, been "growing" up the sides of the mountains; on this postcard, dated November 3, 1907, the sender joked, "A good place for a toboggan slide." (Courtesy of Neil Bush.)

Culture was often available at the Elks Theater (which later was destroyed by fire, then rebuilt). In late December 1907, after Christmas but before New Year's, the Elks hosted the stage play *The College Pennant*. The cast, shown here, is probably taking a bow. (Courtesy of Cochise County Historical Society.)

Soldiers still rode horseback and often visited the city. Here, Lt. Charles Stephens, assigned to Camp Jones, sits astride his well-disciplined mount. (Courtesy of Cochise County Historical Society.)

Other visitors may have included this group of a dozen new second lieutenants of the Ninth Cavalry—probably from Fort Huachuca, west of Bisbee. (Courtesy of Cochise County Historical Society.)

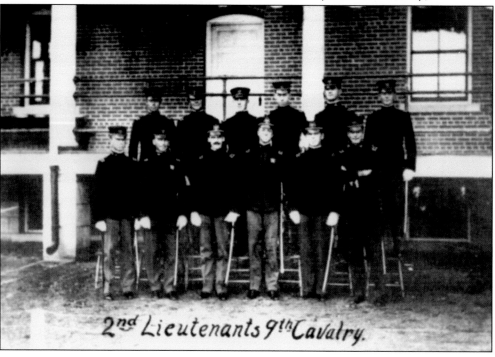

2nd Lieutenants 9th Cavalry.

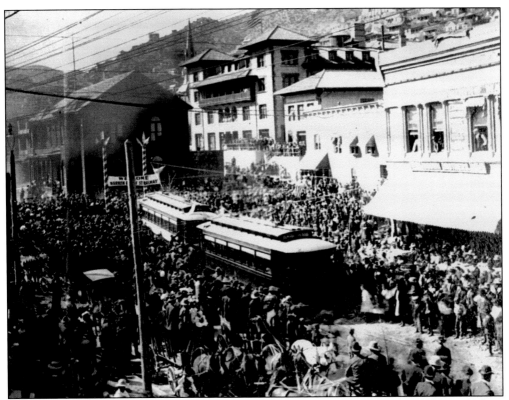

Bisbee was about to become modern, courtesy of an electric railway. Rails would reach from Lowell and Warren all the way to downtown Bisbee! On March 11, 1908, entertainment celebrities, business executives, political leaders, and other visitors—6,000 strong—celebrated. At 2:55 p.m., the first trolley rolled into downtown where 200 of Bisbee's VIPs boarded for its premier excursion. (Courtesy of Bisbee Mining & Historical Museum.)

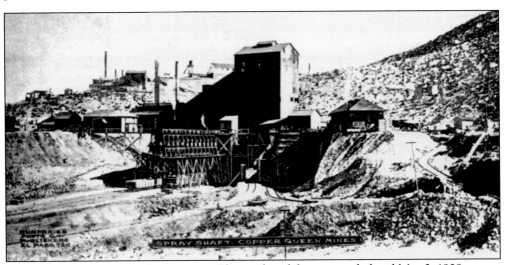

Mining continued to feed the economy. The sender of this postcard, dated May 3, 1908, wrote, "This is a picture of the shaft that R. E. K. has charge of. It is 1048 feet deep and covers a very large territory." (Courtesy of Neil Bush.)

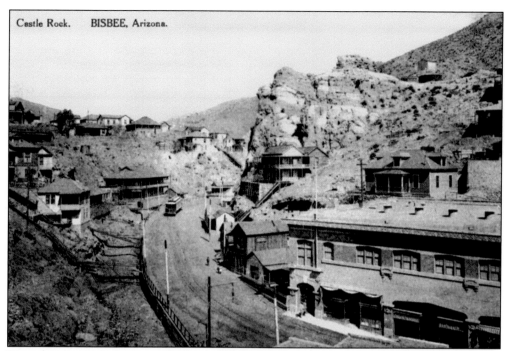

From downtown, looking up Tombstone Canyon, the formerly remote Castle Rock is on the right. The sender of this postcard, dated May 18, 1908, wrote, "The rest of the town is behind the hills. There is only one way of getting in and out of here." (Courtesy of Neil Bush.)

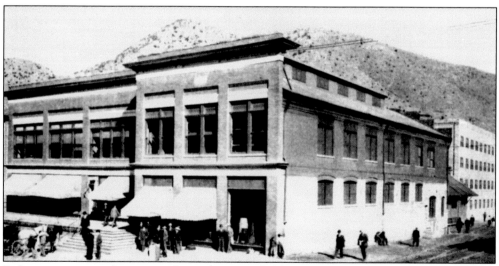

Bisbee was very much a paternalistic town, much like that described in the old Country & Western song titled "16 Tons." Commercial facilities were owned by the company and shopped in by the workers. This is the Copper Queen Company Store and Warehouse. On this postcard, dated June 30, 1908, the sender wrote, "What do you think of our store. It is right up to date." (Courtesy of Neil Bush.)

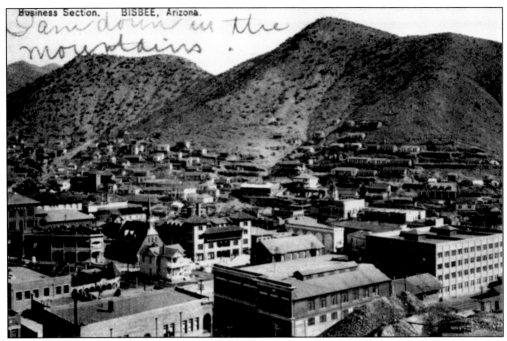

Though the city was photographed before the 1908 fire, this postcard, dated December 14, 1908, shows what it was like. Perhaps the sender wanted folks back home to see Bisbee at its best. The sender wrote, "Have been spending a most enjoyable month here, a town just contrary to the level flowery country I left behind me." (Courtesy of Neil Bush.)

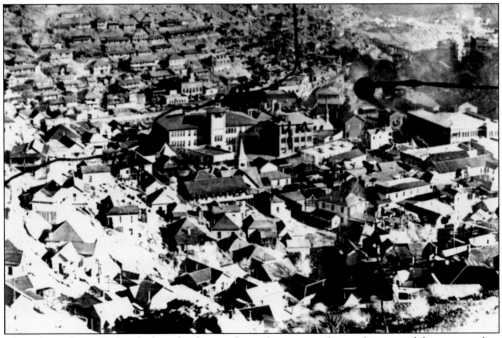

This photo shows Bisbee before the fire, with markings to indicate the part of downtown that was destroyed on October 14, 1908. (Courtesy of Cochise County Historical Society.)

Bisbee was on fire! The blaze allegedly started in either the Opera Club or the Grand Hotel where, it's said, those who discovered it lacked hoses or extinguishers. The alarm was sounded (men firing their guns into the air) and citizens scrambled to keep the blaze from reaching the busy area at the corners of Main Street and Brewery Gulch. (Courtesy of Cochise County Historical Society.)

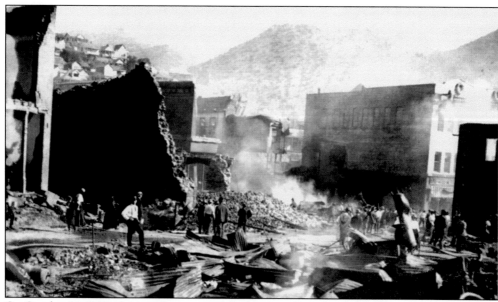

On October 14, 1908, this was the center of the fire zone. Dated a week later, on October 21, 1908, this postcard carries the message, "This is one view of the fire we had here last week. All back of this and across the street and up the hill were all burned." (Courtesy of Neil Bush.)

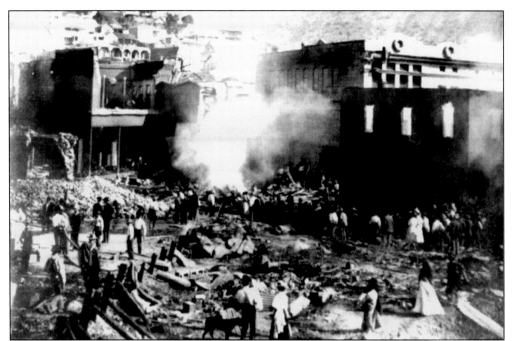

The fire of October 14, 1908, was, by next morning, under control. Stunned citizens were out, surveying the scene, trying to figure out what to do next. (Courtesy of Cochise County Historical Society.)

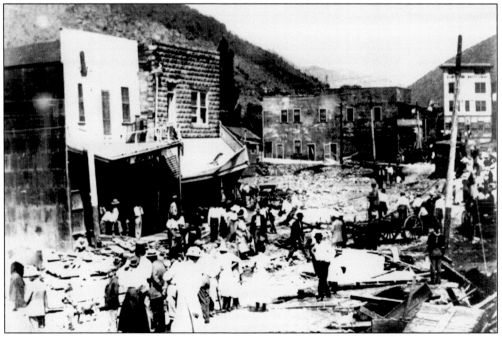

There was devastation everywhere. Businesses were destroyed, leaving little to be picked through for salvage. On the day after, with the acrid smell of smoke and charred wood all about them, men and women began picking up the pieces of their lives. (Courtesy of Cochise County Historical Society.)

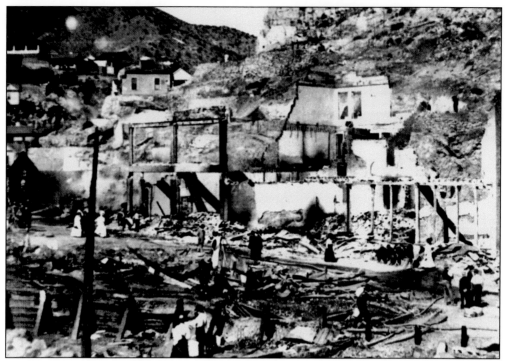

Along many parts of Main Street, smoke still curled up from charred wood. Heartbroken residents might find that the only thing left standing was a portion of someone's wall. (Courtesy of Cochise County Historical Society.)

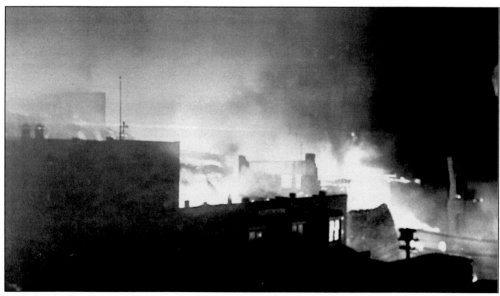

Hellish conflagrations like this one helped make the decision that "something needed to be done." Of course, fires would never be completely eliminated but new and more durable building materials could be used. And the fire department definitely needed updating. (Courtesy of Bisbee Mining & Historical Museum.)

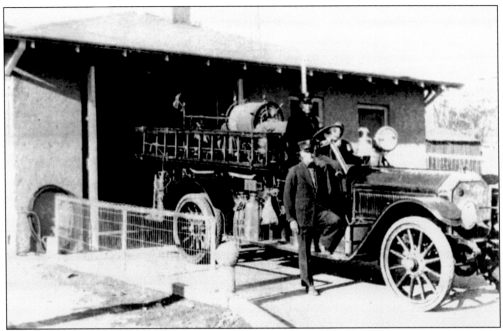

When a fire broke out in the early days of Bisbee, men sounded the alarm by running into the street and firing their guns into the air. A bucket brigade would quickly form. Later modern equipment was purchased—a two-wheel pump cart with 300 feet of hose that could be connected to water at the base of Castle Rock—and, eventually, this state-of-the-art fire truck with chief and firemen in spiffy uniforms. (Courtesy of Bisbee Mining & Historical Museum.)

A city built in a canyon meant special methods were needed to fight fires—or to transport goods. Roads, of a sort, existed but a business outside the valley center meant following mountainous dirt paths. Mules served the purpose well. Here, a loaded pack train is seen wending its way up a crooked path behind the post office. (Courtesy of Bisbee Mining & Historical Museum.)

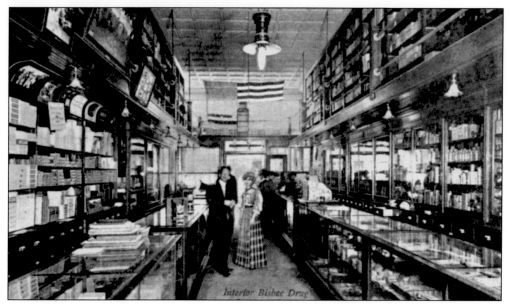

There were no supermarkets or self-serve stores. This promotional postcard, dated December 4, 1909, shows a typical market. It says on the back, "We trust you and your friends will accept this as a personal and cordial invitation to visit our store and inspect the wonderful and beautiful display of Holiday Goods. They are for every age . . . the store is brim full." (Courtesy of Neil Bush.)

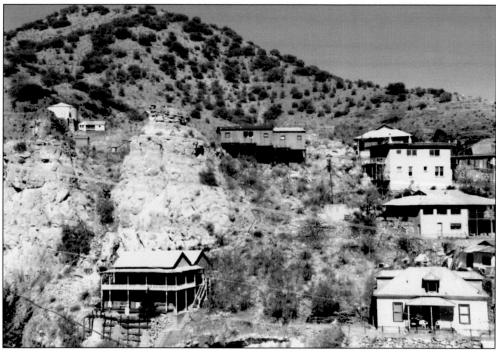

Homes continued to be built on the sides of the mountains, where a small flat area would be scraped out—or "stilts" were used (much as is done on the California coastline of today). This is the area called Castle Rock. (Photo by Ron Price.)

46

Three

MONSOONS AND WAR

Not all of Bisbee was destroyed by the early fires; three-fourths of downtown was, yes, but the parts built mostly of rock or brick managed to survive. Some homes made it, and, of those that didn't, the sites were picked over, cleaned up, and reconstruction soon began.

Bisbeeites have always been survivors. A tough lot, they were not (and are not) prone to wringing hands and wailing "Oh, woe is me!" Instead, after assessing the damage from each disastrous blaze, they may have grieved briefly, but they soon got on with life. A constant influx of new people helped, because they saw what existed at the time of their arrival—not what had once been.

It was a little different with the floods. For instance, residents arriving from the prairie states, where the land was flatter and vegetation different failed to understand weather patterns in the Mule Mountains. They had no knowledge of monsoons, which customarily arrived in early July and lasted through the first half of September. Every summer, there were floods in Bisbee— some more disastrous than others. Once, Nellie Cashman (famously from Tombstone) visited and reported nearly being swept away by the rushing waters. Another time, two miners were trapped in their living quarters and were drowned before being able to escape.

But Bisbee survived. Bisbee thrived. Bisbeeites rebuilt.

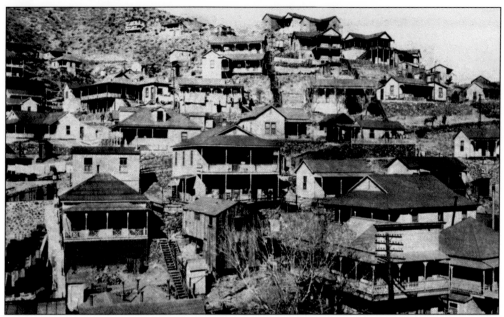

The stairs (near the bottom of the picture) leading from the street to the house is one method of adapting to Bisbee's topography. The sender of this postcard, dated May 17, 1909, wrote, "What would you think of the ups and downs of living in a place like this? Just an excursion trip will do here." (Courtesy of Neil Bush.)

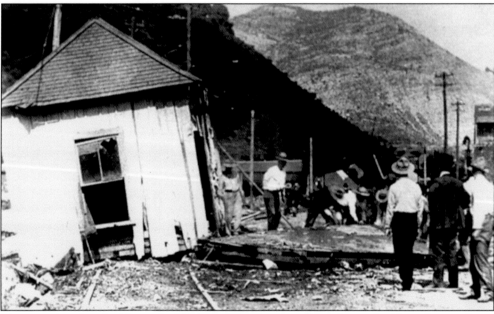

They continued to build—and, oblivious to the patterns formed, to rebuild, as shown above. Fires happened and, unfortunately, fire wasn't the only disaster to befall Bisbee. Newcomers continued to misunderstand summer monsoons, when several inches of rain could fall with minutes. Funneled by rocky gullies, destructive torrents crashed down rocky mountainsides, taking with them anything that could be moved. An example of the damage is shown in this c. 1910 photo. (Courtesy of Cochise County Historical Society.)

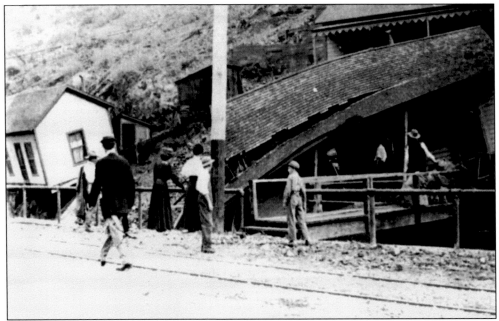

Luckily, people usually escaped death in the annual monsoon floods. (There was an exception once, when two miners were trapped in their quarters—but not this time). The rails survived, so transport was available. Some salvage was realized. As usual, men, women, and children gathered to view the devastation, as they did in this *c.* 1910 photo. (Courtesy of Cochise County Historical Society.)

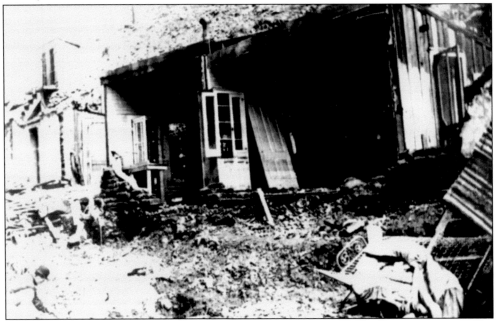

Half of the wooden home in this *c.* 1910 photo was washed away, destroyed. The remainder was probably unsalvageable, having been knocked off whatever foundation existed. Perhaps a few personal belongings were rescued when the people who lived here picked through the muck and mess. (Courtesy of Cochise County Historical Society.)

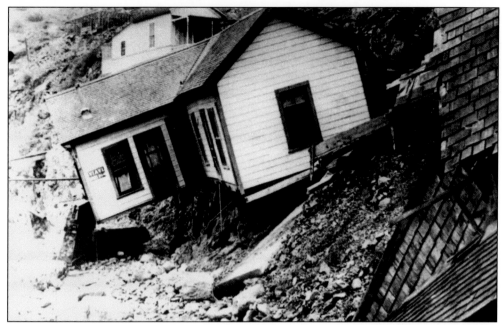

This *c*. 1910 photo shows another small wooden home that may be fixable. Instead of the monsoons washing it down from a site higher on the mountain, it appears that the very earth under it was washed away, while a home right behind it remains in place. (Courtesy of Cochise County Historical Society.)

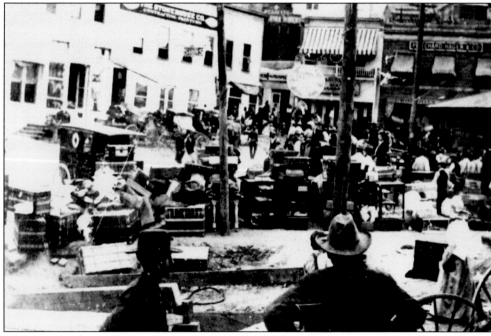

Meantime, as this *c*. 1910 photo shows, many were left homeless—some with only the clothes on their backs, some who at the first thunderclap went to higher ground, taking a few belongings with them. When the flood was over, they were left to be what today are called street people. The condition wouldn't last long. (Courtesy of Cochise County Historical Society.)

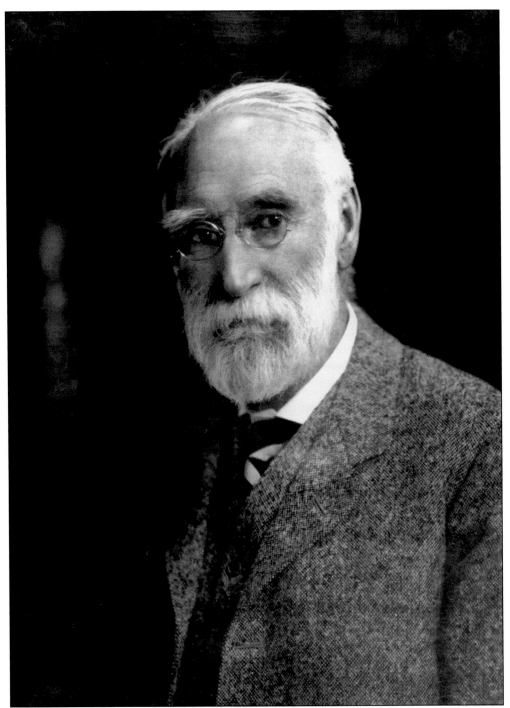

James S. Douglas was a man with ancestral roots in Scotland but born in Quebec, Canada. Trained to be a Presbyterian minister, Douglas was a quiet, intelligent man. By a circuitous route, he became associated with Phelps-Dodge Corporation and would have a profound effect on the history and the future not only of Bisbee, but also the nearby City of Douglas. (Courtesy of Bisbee Mining & Historical Museum.)

James Douglas married Naomi Douglas, a Scotswoman and the daughter of Capt. Walter Douglas (no blood relation to James), and she presided with decorum over a well-kept household. Their youngest son would be named Walter, after his grandpa, and would follow in his father's professional footsteps. (Courtesy of Cochise County Historical Society.)

As an adult, Walter Douglas acquired a home that had earlier belonged to Lewis (aka Don Luis) Williams. The home included this sunny parlor. (Courtesy of Cochise County Historical Society.)

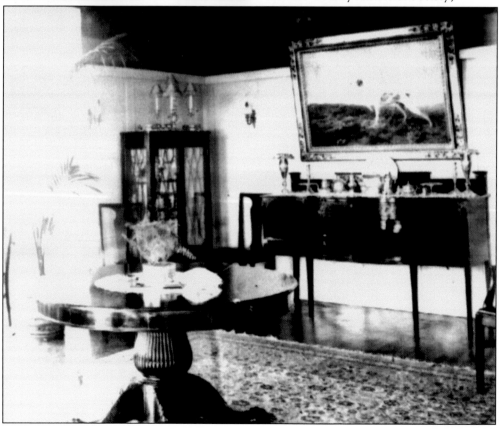

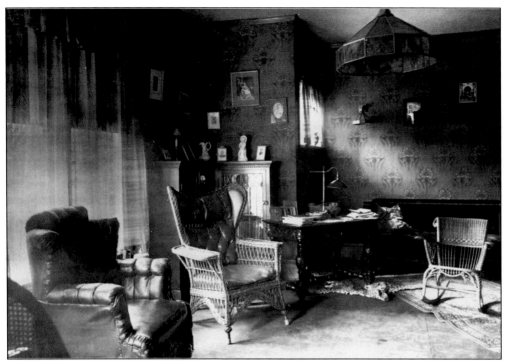

This photo shows another example of the Douglas family's well-appointed living room. Notice the leopard skin rugs under the table. (Courtesy of the Bisbee Mining & Historical Museum.)

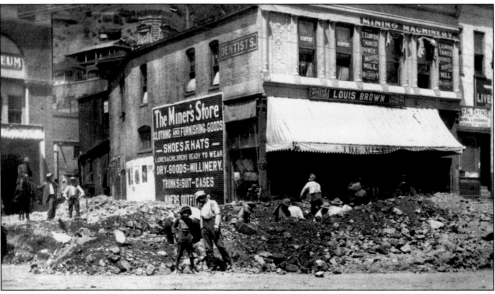

This *c.* 1910 photo shows the aftermath of another storm in Bisbee. This scene is at the intersection of Main Street and Brewery Gulch. The Orpheum Theater is at the far left, the Miner's Store is featured, and the edge of what would be the Lyric Theater is on the far right. This time, most "executive homes" survived, but there was a lot to pick through downtown. (Courtesy of Bisbee Mining & Historical Museum.)

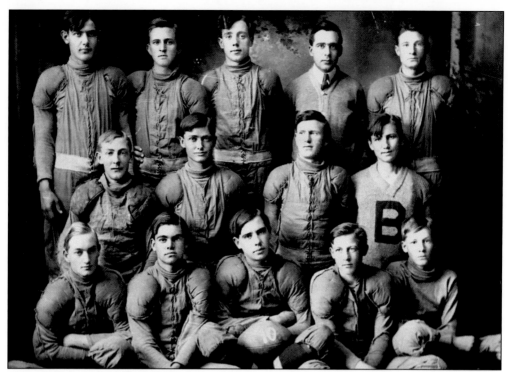

Through fire and flood, the city kept its spirits up. Perhaps one thing that helped was the high school's sports program because families could attend and cheer on the players. This is the 1910 Bisbee football team (individuals not identified) from Central School. Just look at those snazzy first-rate uniforms with the impressive shoulder pads! (Courtesy of Bisbee Mining & Historical Museum.)

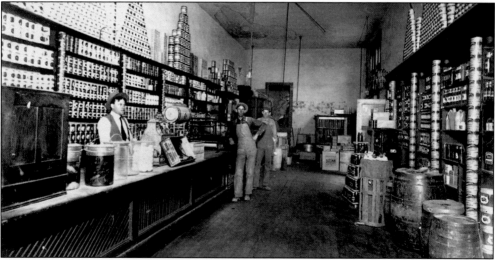

The interior of a Bisbee grocery store, c. 1910, reveals no checkout lanes or self-serve shopping. A clerk waited on customers from behind a counter. A customer asked for what he or she wanted and the clerk would get it. See the pickle container on the counter at the clerk's elbow? And a big jar of boiled eggs (probably pickled) just over from it? (Courtesy of Bisbee Mining & Historical Museum.)

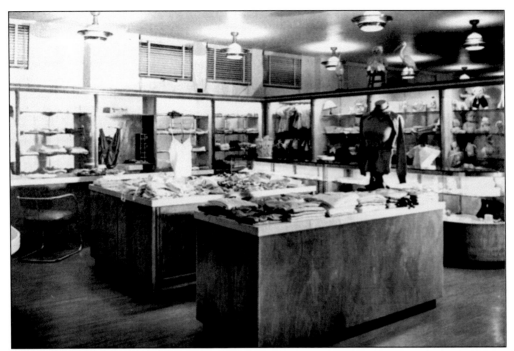

This is the ladies department of a dry goods store. Being empty of customers, one supposes it was early in the day or a Sunday, when "Blue Laws" forbade most commerce. Part of the theory was that Sunday was "a day of rest" and for going to church. If a store (even a grocery store) was open, people generally would not patronize. (Courtesy of Bisbee Mining & Historical Museum.)

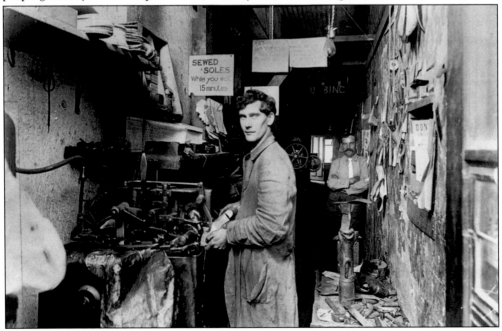

A shoe repairman, c. 1910, is hard at work while a gentleman waits, arms crossed. The shop was located in Lowell, which became part of Bisbee. (Courtesy of Bisbee Mining & Historical Museum.)

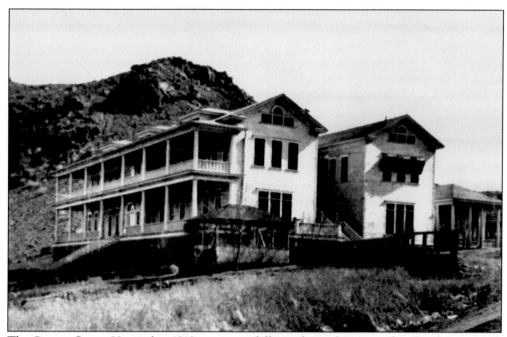

The Copper Queen Hospital, c. 1910, was quite different from what it is today. On this postcard, dated simply "1910," the sender wrote, "How would you like to be a nurse. A new hospital just open, round by the Copper Queen." (Courtesy of Neil Bush.)

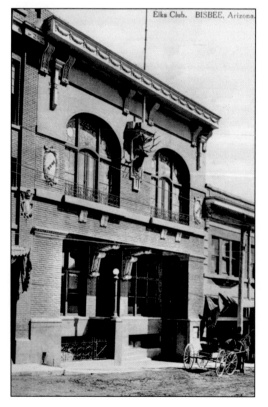

The original Elks Club, possibly the one with the parades and stage entertainment, was destroyed in the 1908 fire. It was rebuilt (shown here) in 1910. Notice the horse, hitched to a nice spring wagon, waiting patiently for his owner to come out and continue on his way. (Courtesy of Bisbee Mining & Historical Museum.)

In 1910, Arizona was not yet a state, although it was a territory, and the southern part, where Bisbee came to be, had once been Sonora, Mexico. The area continued to have plenty of important visitors from south of the border. One such visitors was Plutarcho Elias Calles, president of Mexico. (Courtesy of Cochise County Historical Society.)

Although automobiles existed, a lot of transportation was still by horse and buggy. An example is this photo, c. 1910, with Michael J. Donohoe and his daughter Ruth Katheryn. (Courtesy of Cochise County Historical Society.)

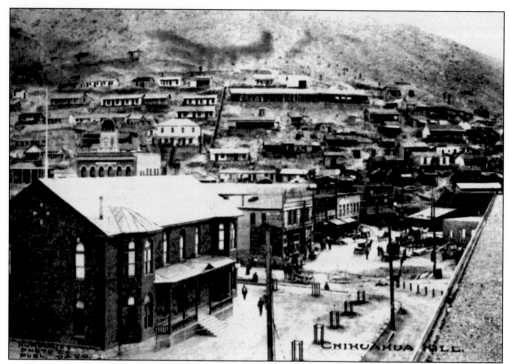

Earlier typhoid outbreaks were exacerbated by sanitation problems on Chihuahua Hill. Improvements were made and Bisbee continued to grow. On this postcard, dated December 27, 1911, the sender wrote, "This is a mining town of 18,000 people. Good business town also." (Courtsey of Neil Bush.)

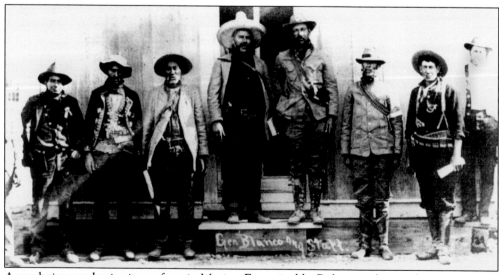

A revolution was beginning to form in Mexico. For a city like Bisbee, so close to the international border, there was definitely some concern. Shown here are Gen. Lucio Blanco (who supported Francisco Madera) and his staff. (Courtesy of Cochise County Historical Society.)

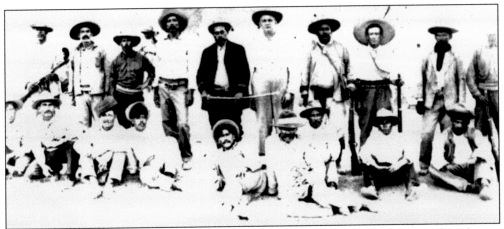

Called *insurrectos*, this group, *c.* 1910, stands ready for battle during the Mexican Revolution. It's the Red Lopez Group (that's Lopez in the center, holding a saber). Not all insurrectionists carried Spanish names. Sixth from left is Tom Merritt and third from right is George Luess. (Courtesy of Cochise County Historical Society.)

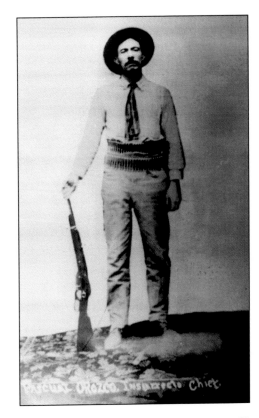

Keeping in mind that the insurrection began around 1910 or 1911, it's obvious that not everyone had the most modern equipment. This "soldier" stands with his ammo belt and rifle—a Model 1895 Winchester! (Courtesy of Cochise County Historical Society.)

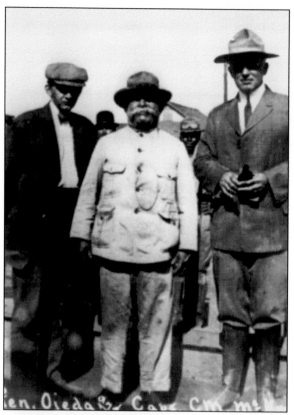

While Bisbee's mines kept producing, leaders kept a wary eye on border conditions. Here are Gen. Pedro Ojeda (center) and Capt. Charles McKeen to the right. McKeen, a former Army man, walked into battle carrying a white flag and negotiated safe passage for Ojeda's surrounded troops. (Courtesy of Cochise County Historical Society.)

The arguably most famous individual in the Mexican Revolution was Pancho Villa. Some of his ethnic-Indian recruits are shown here. (Courtesy of Bisbee Mining & Historical Museum.)

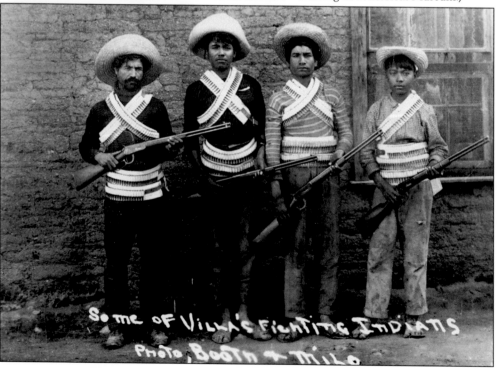

Four

A City of Many Parts

The second decade of the 20th century was one of tremendous change for Bisbee. One wonders if the general population realized the danger as they went about their daily lives, but it's certain that businessmen, civic leaders, and mining executives were concerned. After all, the land where Cochise County and Bisbee now exist was once part of Mexico (after it had been taken from the Apache Nation), then sold to the United States—during which it was part of the Territory of New Mexico, then the Confederate States of America, back to the United States of America, the Territory of Arizona, and finally, on February 14, 1912, the State of Arizona. It didn't stop there. Before there was a Cochise County, it was all Pima County, one the original four in Arizona.

So Bisbeeites had always been subject to the uncertainty of territorial fluctuations. Mix in the fact that the miners and their families all came from somewhere else, with few family ties and little cohesion. Not only was there an obvious "pecking order" among the different ethnic groups in the mining industry, but the groups were not well integrated.

It created a city that was, on the surface, upbeat and progressive. There were schools, churches, shops, stage productions, football games, ladies and "soiled doves." Underneath, there was turmoil. For instance, Bisbee was multi-layered and actually quite segregated. At one point, the Chinese were not allowed in town after dark and mine workers from south of the border were relegated to the poorer jobs. Those of European backgrounds were given jobs according to what part of Europe they came from. Bisbee could, in some ways, have been compared to a duck—calm on the surface, but paddling like mad underneath. Trouble was waiting to happen.

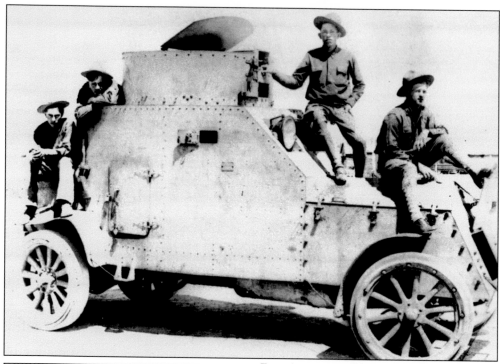

Four American soldiers, in uniform, sitting on a WWI–era tank. They're probably guarding the international border between Arizona and Mexico. Because the Mexican Revolution went from about 1910 to 1920, during which Arizona gained statehood, troops from this side of the border were definitely involved. (Courtesy of Cochise County Historical Society.)

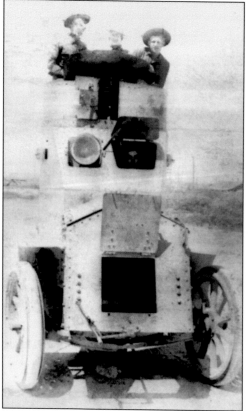

This was an armored vehicle of the United States Army, a reminder that the Mexican Revolution was happening and people on this side of the border might be vulnerable. Some Bisbeeites, however, probably didn't take it seriously. They traveled to nearby Naco and watched some of the conflict unfold—as though it were a show put on for their benefit. (Courtesy of Cochise County Historical Society.)

Business went on in the one-industry town. Regardless of the turmoil outside of the canyon, outside the Mule Mountains, mining would go on. This is the Shattuck-Denn Concentrator, c. 1910. (Courtesy of Cochise County Historical Society.)

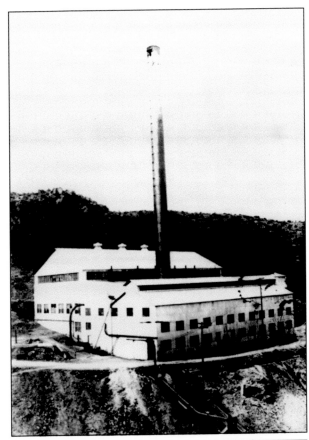

There'd be Tintown and Chihuahua Hill, of course, but more luxurious properties were usually built closer to downtown. This is one incarnation of the YMCA (once a private home),c. 1911, where gentlemen could stay for a reasonable fee. Notice the stairs and terraced landscaping, necessary to make construction fit a modified topography. (Courtesy of Cochise County Historical Society.)

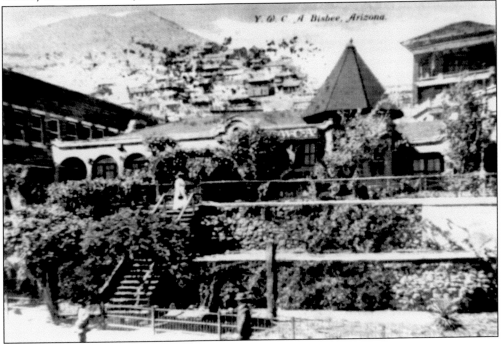

63

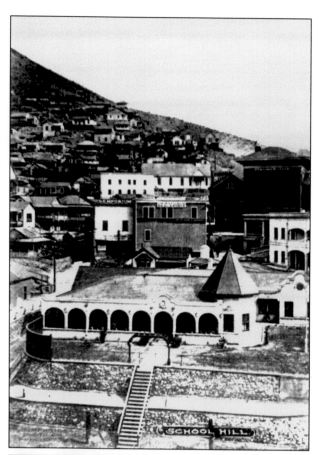

This is another view of the YMCA, of which Bisbee was quite proud; that's it, with the turreted roof. This photo was taken from School Hill looking across to Quality Hill. (Courtesy of Cochise County Historical Society.)

Downtown, commerce continued to grow. Bisbee had a streetcar, although some clung to using a horse and buggy. (The streetcar is gone but these buildings are still there.) The sender of this postcard, dated November 19, 1912, wrote, "How do you like the looks of our Bisbee street." (Courtesy of Neil Bush.)

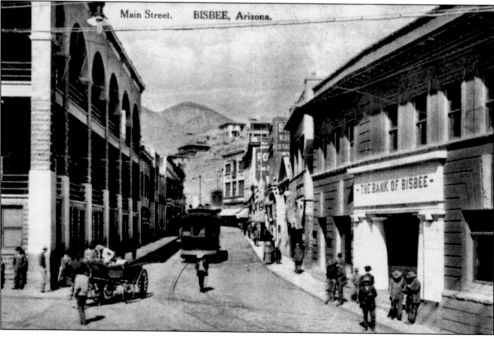

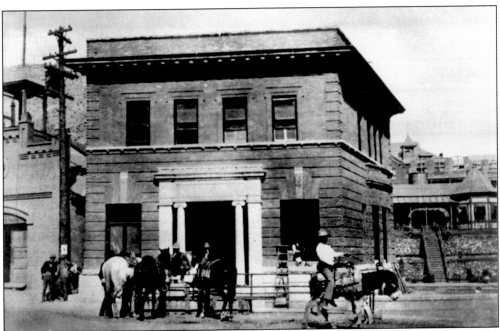

Horses, burros—if it could be ridden, it became transportation when one simply had to go to the bank. (Courtesy of Bisbee Mining & Historical Museum.)

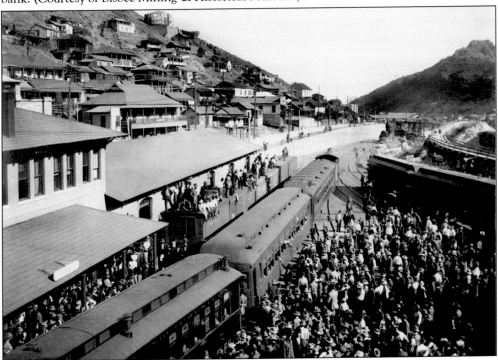

Bisbee was affected by the turmoil in Europe. Shown here in 1912, a train loaded with volunteers is ready to leave the Bisbee rail yard; the men are on their way to fight a war in the Balkans as family and friends gather to see them off. Some would return, some wouldn't. (Courtesy of Bisbee Mining & Historical Museum.)

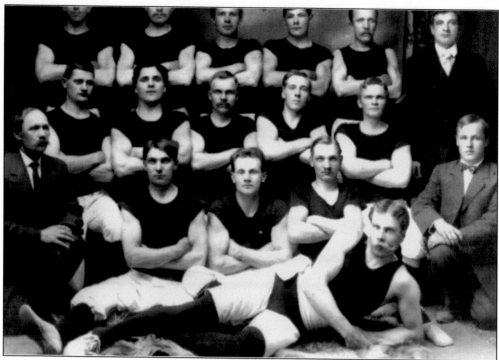

Not everyone volunteered for the Balkans. This is the Finlander Athletic Society of 1912; all members of the society worked in the mines. That's A.E. Waisanen in the center, next to top row. (Courtesy of Cochise County Historical Society.)

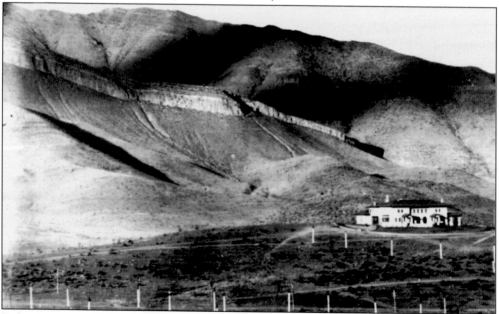

Bisbee continued to grow. The new Walter Douglas home, shown here c. 1912 (the same year Arizona became a state), started "way out in the country," but wouldn't be remote for long. The markers in the foreground show where the Warren Townsite was staked out. Later, Warren would be absorbed by Bisbee. (Courtesy of Cochise County Historical Society.)

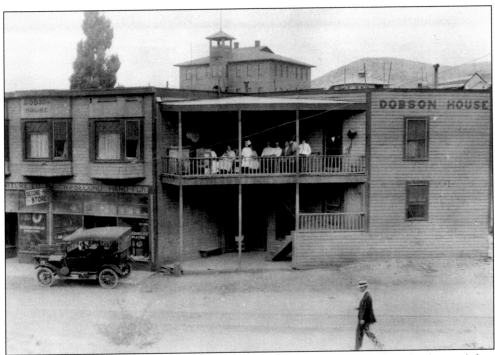

In 1912, at the same time Warren Townsite was laid out, the Finnish Boardinghouse (a.k.a. Dobson House)—located in what was called Jiggerville—was the home of mine employees who came from Finland. Several brought their wives and families with them. (Courtesy of Bisbee Mining & Historical Museum.)

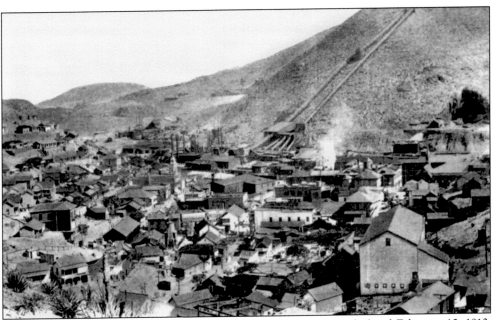

This was Bisbee, seen from Opera Hill. The sender of this postcard, dated February 10, 1913, wrote, "Bisbee, Arizona, a mining town built upon the sides of the mountains and the mines are higher up." (Courtesy of Neil Bush.)

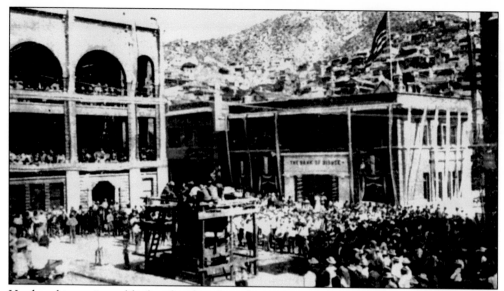

Hard-working miners liked to let their hair down. One way was the Annual Fourth of July Drilling Contest, held after a big parade. Crowds lined balconies and crowded the streets. The sender of this postcard, dated July 7, 1913, wrote, "Had a good time on the Fourth, lively parade." (Courtesy of Neil Bush.)

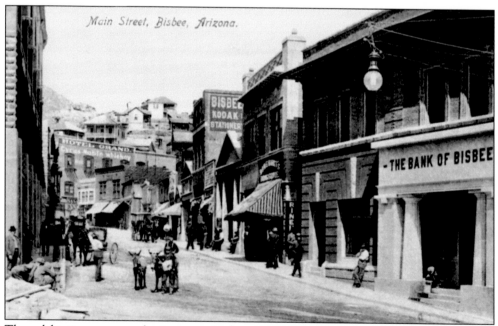

The celebration was over, business was back to normal, and Bisbee could only be called "hot and humid." Without knowing the monsoons were due, the sender of this postcard, dated July 7, 1913, wrote, "Hot as it can be. Had a nice shower last night and cooled off some." (Courtesy of Neil Bush.)

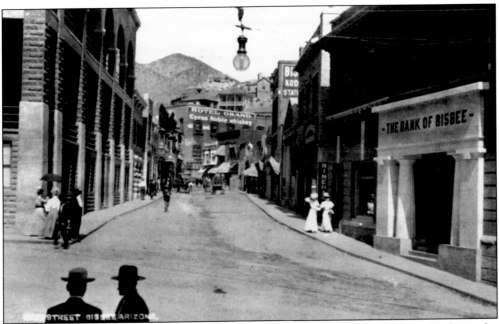

After the monsoons, weather turns delightful and fashionable ladies can stroll down the sidewalks. The sender of this postcard, dated October 6, 1913, wrote, "Am very busy, and am liking Bisbee just fine now. Am having a good time, and enjoying the best of health, but am not sushing [*sic*] the fairer sex very much." (Courtesy of Neil Bush.)

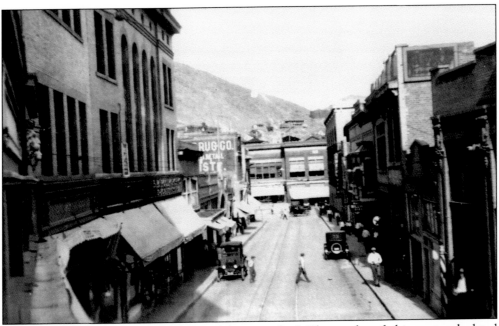

Bisbee was becoming modern. Automobiles were "in." The sender of this postcard, dated January 12, 1914, wrote, "Am very busy with business and social affairs. I certainly wish your people there could enjoy the dandy weather we have here. It is simply grand." (Courtesy of Neil Bush.)

Even tall buildings were close together but with walk space between, room enough for two friends and a dog. The sender of this postcard, dated July 8, 1914, wrote "Have run into a number of friends of yours around here." (Courtesy of Neil Bush.)

Like submarines, mines deep in the earth have narrow passageways and, without some form of light, they're dark! An example of one's surroundings deep inside such a mine is this one c. 1913, showing a mule pulling an ore car out of the czar mine. Three miners attend. See the name "Harry L. Crockett" over their heads? (Courtesy of Bisbee Mining & Historical Museum.)

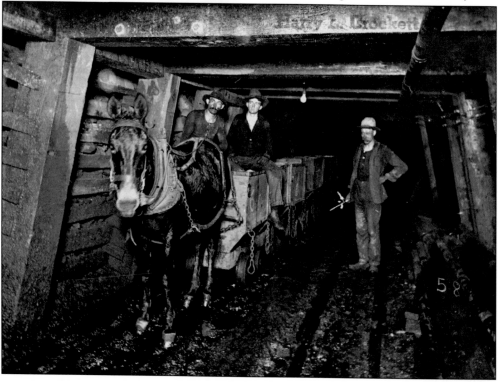

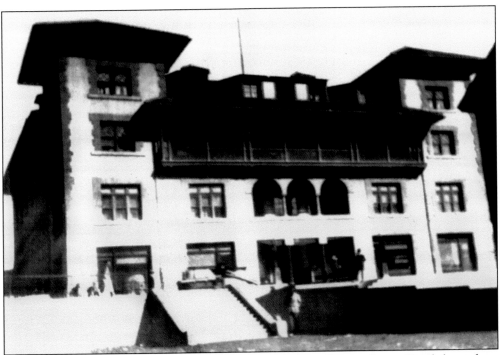

Above ground, life went on, sometimes quite elegantly. The Copper Queen Hotel shown here c. 1915, was and is one of the finest. (Courtesy of Cochise County Historical Society.)

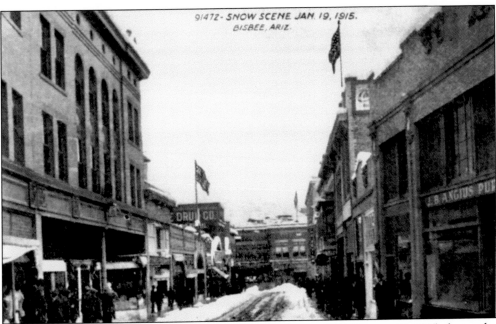

Snow happens in Bisbee, mostly because of its mile-high status. On January 19, 1915, the sender of this postcard wrote, "When I came out here, I thought I wouldn't have much to do, but I seem to have more than ever. We had six inches of snow yesterday. The most ever." (Courtesy of Neil Bush.)

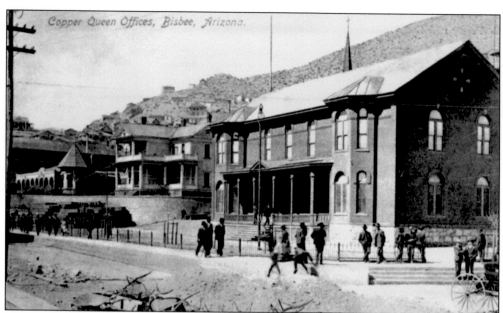

The Copper Queen offices were housed in this fine building. The sender of the postcard, dated February 16, 1915, wrote, "I like it good down here, the boarding is fine . . . the mines are the only kind of works here, lots of them . . . I take a trip around the mines every day." (Courtesy of Neil Bush.)

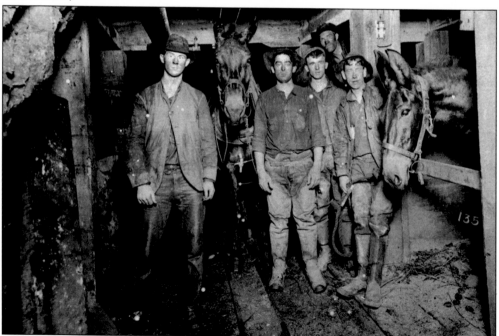

Even in 1915, conditions weren't always modern, as we think of the word today. Because of the steep hillsides, burros and muleswere still used—as here—to haul timbers to the mines or bring the rich ore to the surface. It's said that some animals lived their entire lives underground. Open pit mining was on the way, though, and would bring many changes. (Courtesy of Bisbee Mining & Historical Museum.)

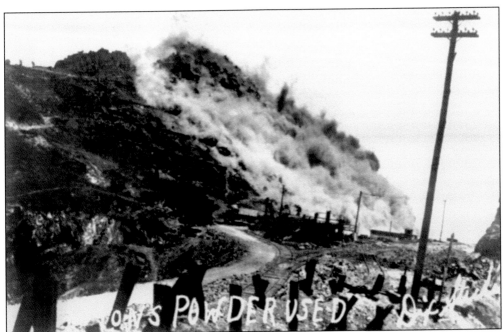

Dynamite can change the face of the land. An example is the mine started at Sacramento Hill on June 1, 1917, when 10 tons of powder was exploded. The sound reverberated off the mountains and the earth shook—quite like an earthquake. (Courtesy of Cochise County Historical Society.)

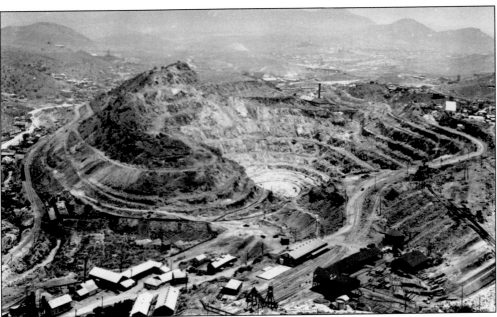

As telephones spread across the country, needing copper for the wires, Bisbee's rapid growth was linked to the popularity of telephones. Mines worked 24 hours a day. Open pit mining cost less and the Sacramento, c. 1919, looked like this before the landscape was changed forever. In the foreground is the Copper Queen's Czar Works but today, the mountain is not really there. (Courtesy Bisbee Mining & Historical Museum.)

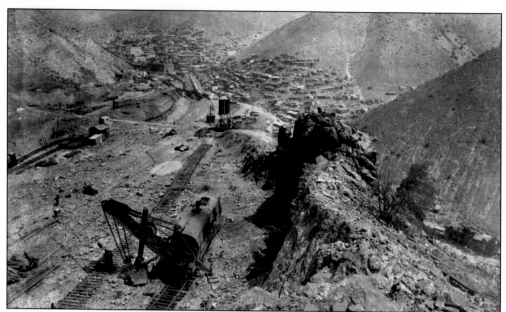

Steam shovels work in the Sacramento Hill open pit mine, *c.* 1919. Animals were no longer necessary but the noise greatly increased (and maybe caused some hearing problems). This affected townspeople because, as can be seen, the mines and the city were nextdoor neighbors. (Courtesy of Bisbee Mining & Historical Museum.)

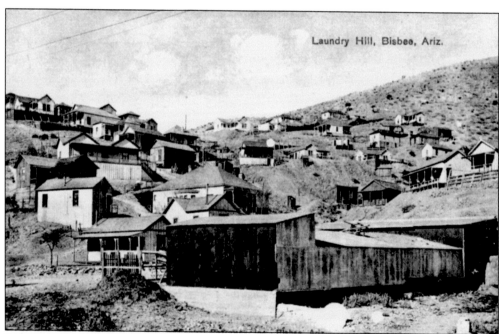

Bisbee's high altitude will, at first, affect one's breathing. One "Laundry Hill" newcomer wrote on this postcard, dated August 2, 1917, "I sure do live right up the side of the mountains, but it is nice after one gets up here. I haven't learned to walk and breathe good at the same time but I will soon so I can climb like the rest of folks." (Courtesy of Neil Bush.)

Five

THE DEPORTATION

Both World War I and the Mexican Revolution made copper important, and Bisbee allegedly produced 10 percent of the world's output. In addition, copper from the mines at Cananea, Mexico, came up through Bisbee. Other copper-producing towns in Arizona were Clifton-Morenci, Globe-Miami, and Jerome, where wages were based on what was paid in Clifton-Morenci. Some objected, wanting more.

Enter the Industrial Workers of the World (IWW), with ties to England and France. Members were commonly called "Wobblies." After instigating a strike in Jerome, they turned their attention to Bisbee. When problems in the Warren Mining District started, inflammatory news articles certainly didn't help! Eventually the sheriff, Harry Wheeler, came down from Tombstone (the county seat at the time) to see what could be done.

Keep in mind that this was June 1917. The war in Europe was still raging, tempers were short, and fear was rife. The Wobblies had already made their presence felt in Jerome and Clifton. Still, the strike in Bisbee actually began quite peacefully, although it soon escalated. How much of the cause was fact and how much was rumor? It depends on who's talking.

THE BEGINNING OF A BETTER DAY

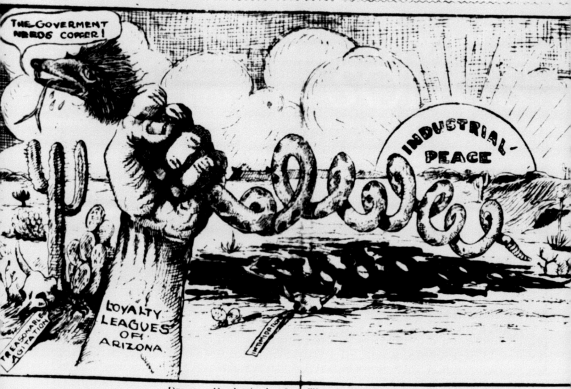

Drawn Exclusively for The Daily Review.

A cartoon published in the *Daily Review*, then owned by the Phelps-Dodge Corporation, attempted to explain the newspaper's viewpoint. An earlier recession caused miners to leave Bisbee and relocate to support their families. Bisbee survived and the economy completely rebounded. The corporation wasn't about to let go of that—and remember, the *Review* was owned by the corporation (as was the *Tucson Citizen,* which also reported on unfolding events). So when the IWW came a'calling, the paper fought back with articles explaining that the union was inciting riots and its people were "outsiders." Certainly its speakers knew how to work a crowd. The mix of native languages probably added to communication problems, and miners were probably less educated, a little more naïve, some of them a little easier swayed by the charismatic speakers. (Courtesy of Bisbee Mining & Historical Museum.)

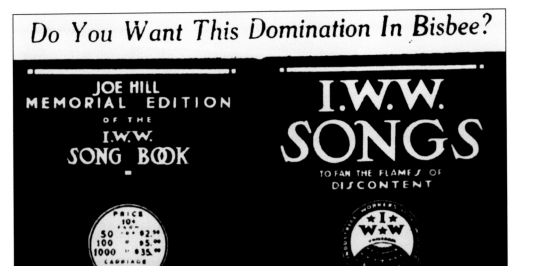

Do You Want This Domination In Bisbee?

JOE HILL
MEMORIAL EDITION
OF THE
I.W.W.
SONG BOOK

PRICE 10 CENTS

ADDRESS
I.W.W. PUBLISHING BUREAU
112 HAMILTON AVE., CLEVELAND. OHIO
U.S.A.

I.W.W.
SONGS
TO FAN THE FLAMES OF
DISCONTENT

JOE HILL

PUBLISHED BY
I.W.W. PUBLISHING BUREAU
112 HAMILTON AVE. CLEVELAND. OHIO
U.S.A.

The IWW sent experienced speakers who used every known tactic to add to their roster. Using age-old methods of converting crowds, they encouraged the audience to join in singing from a songbook titled "I.W.W. Songs," subtitled "To Fan the Flames of Discontent." Of course, the songbooks weren't free; audiences were encouraged to buy a copy. (Courtesy of Bisbee Mining & Historical Museum.)

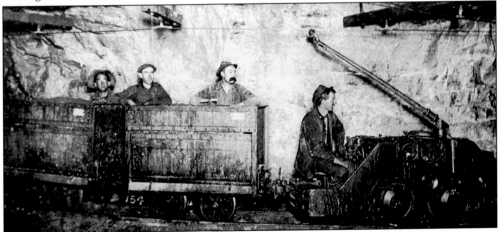

Still, workers had to feed their families. They needed a place to live. And they continued to go down into the mines . . . as these men are doing. (Courtesy of the Bisbee Mining & Historical Museum.)

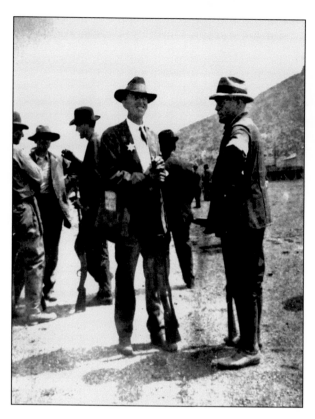

Events were about to come to a head. Shortly after midnight on July 12, 1917, phones rang to summon deputies. A roundup began. The "good guys," many of them deputized over the phone, would wear white armbands to identify themselves. That's Sheriff Wheeler wearing his badge, and Captain Hodgson on the right. (Courtesy of Bisbee Mining & Historical Museum.)

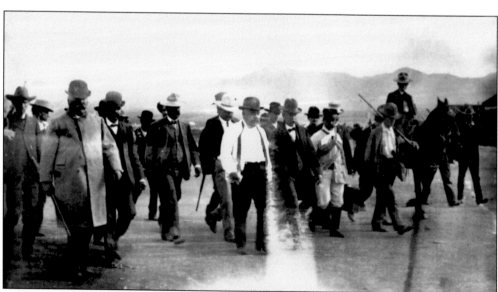

Strikers gathered in front of the downtown post office. At 6:30 a.m., deputies came from three directions, surprising the picketers. Sheriff Wheeler ordered deputies to collect sympathizers who might be in Bisbee, after which they were marched, under armed guard, to the ballpark in Warren. (Courtesy of Bisbee Mining & Historical Museum.)

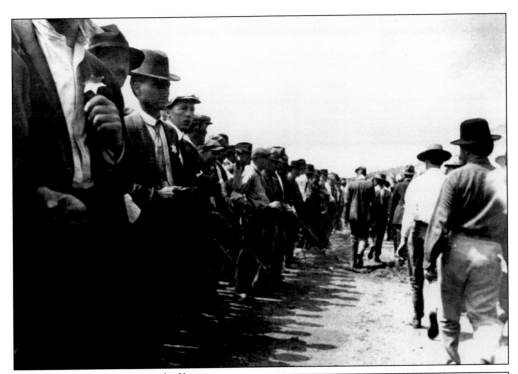

Then, anyone even suspected of being an IWW sympathizer was wakened by pounding on the door and the shouted question "Are you working?" (A "no" answer, given for whatever reason, brought one into the roundup.) As the "parade" made its way to the ballpark, residents came out to watch, as if in celebration. Many walked alongside the miners, outside the perimeter formed by the guards. Once the strikers were gathered in the ballpark, Sheriff Wheeler separated them into two groups, according to whether they were willing to go back to work. Most did, and were let go. Some did not. The roundup was humiliating but a more devastating event was to begin later that same day. (Courtesy of Bisbee Mining & Historical Museum.)

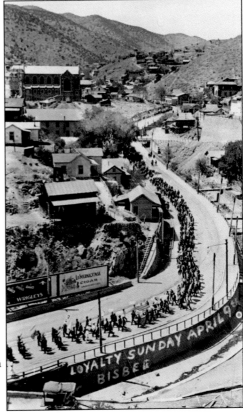

Once rounded up, it was a long walk for everyone involved—and it wasn't exactly level ground. For some, it was a day of great celebration (hence the flag, etc.) that would go down in history. For the miners, for the "Wobblies," it wasn't so glorious. Certainly, most of the deported miners would never return and the day of their removal was the last time they'd ever see Bisbee. (Courtesy of Bisbee Mining & Historical Museum.)

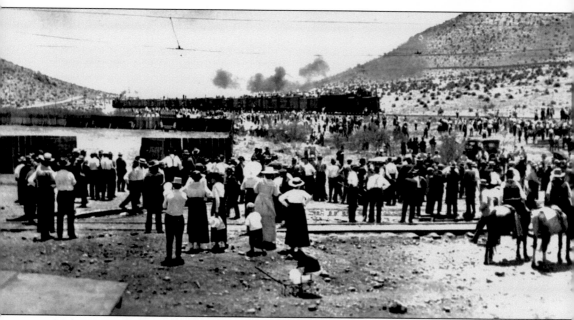

It's been reported in the newspapers that on July 12, 1917, at about 11 a.m., more than a thousand men were herded into boxcars, neither they nor their families knowing what would happen. They were taken on a two-day trip into the New Mexico desert (not "Mexico" as some mistakenly have said; they were never taken out of the United States). They went first to Columbus, New Mexico, and then, when there were no accommodations, back into the desert to wait overnight. The Army had a skeleton crew on site at Columbus, left over from a year earlier when Pancho Villa raided the town. Upon hearing what had happened, they were instructed to handle it. The soldiers set to making tents and rations available. It was welcome. Some of the dissidents had been taken before they'd had breakfast, and others were hardly dressed. At first, the exiles kept busy hauling firewood and digging latrines. Three days after the fracas began, the deportees got their first coffee. Some would leave camp at Columbus; some would try returning to Bisbee (and a few were promptly arrested as vagrants). Some would join the Army. (Courtesy of Bisbee Mining & Historical Museum.)

Though the deportation made the national news, including *The New York Times*, small heartwarming events kept some parts of Bisbee grounded. One such event was the June 5, 1917, flag raising (by the Boy Scouts) on Bucky O'Neil Point. (Courtesy of Bisbee Mining & Historical Museum.)

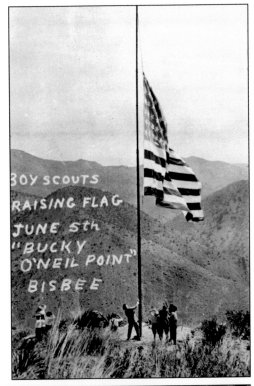

Regardless of what went on above ground, miners still had to feed their families, and they continued to go down into the mines, as this man is doing. (Courtesy of Bisbee Mining & Historical Museum.)

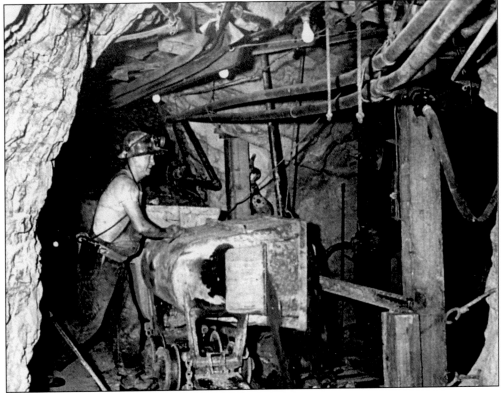

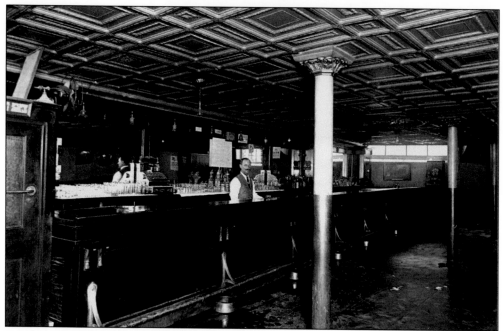

Popular, top-quality "watering holes" kept busy, and the businessmen and guests found them quite comfortable. Some were quite luxurious. See the ceiling? Prohibition was on the way (when some drinking establishments became ice cream parlors) but it wasn't here yet! (Courtesy of Bisbee Mining & Historical Museum.)

On the surface, nothing much changed in downtown Bisbee. The sender of this postcard, dated September 20, 1919, wrote, "Arrived ok and feel just fine. The old place hasn't changed any." (Courtesy of Neil Bush.)

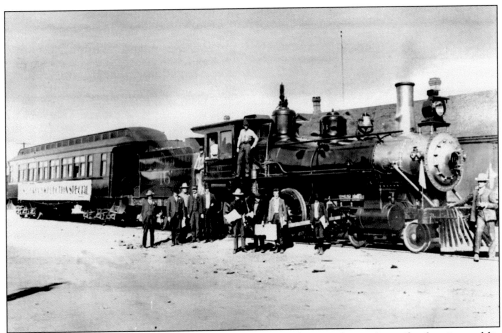

Pulling out all stops, this *Bisbee Review Election Special* came down the rails, drawing public attention to its chosen representatives. From events such as this came the term "whistle-stop." (Courtesy of Bisbee Mining & Historical Museum.)

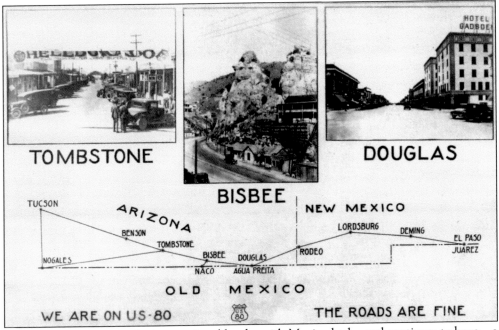

Perhaps its proximity to the international border with Mexico had—and continues to have—a big effect on the city . . . that, and the fact that the tunnel was in the distant future. The sender of this postcard, dated April 29, 1920, wrote, "Arrived in Bisbee last night about 11:00 p.m.— awful road, don't ever think of driving through." (Courtesy of Neil Bush.)

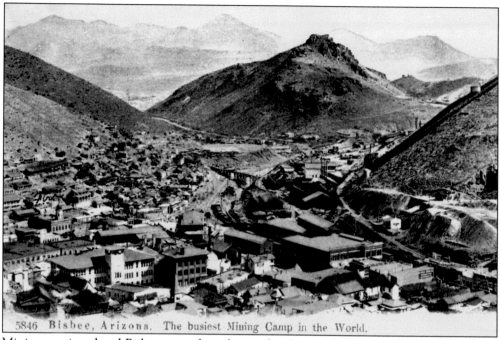

5846 Bisbee, Arizona. The busiest Mining Camp in the World.

Mining continued and Bisbee was a fine place to be. Summer was particularly desirable. The sender of this postcard, also dated April 29, 1920, wrote, "I like Bisbee very much, what I have seen of it." (Courtesy of Neil Bush.)

Mining gave growth to other industries. This is the Bisbee-Shattuck Lumber Yard in Brewery Gulch. (Courtesy of Bisbee Mining & Historical Museum.)

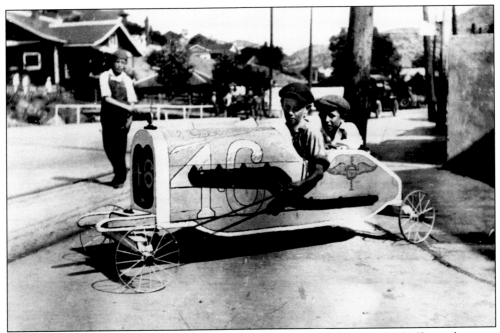

Boys and young men will be boys and young men. It was no different *c.* 1920. Shown here are three with a racer built by George Sellers. The driver is Kenneth Sellers and the brakeman is Paul Sanders. (Courtesy of Bisbee Mining & Historical Museum.)

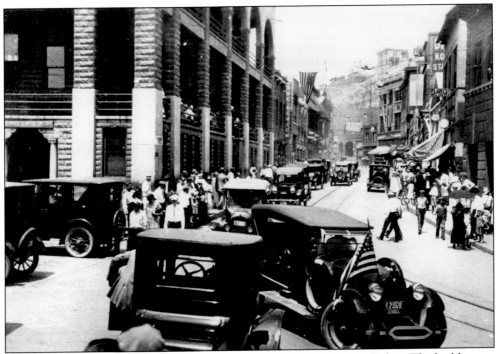

Adults drove cars of a different sort. This is Main Street in downtown Bisbee. The building on the left, the post office downstairs and the library upstairs, is just about as it is today. (Courtesy of Bisbee Mining & Historical Museum.)

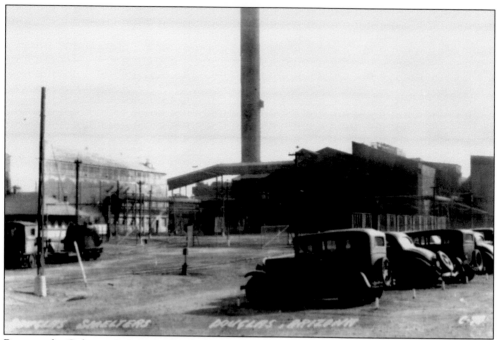

Because the Calumet & Arizona Smelter was now in Douglas, many Bisbeeites drove their modern automobiles to work or do business there. (Courtesy of Cochise County Historical Society.)

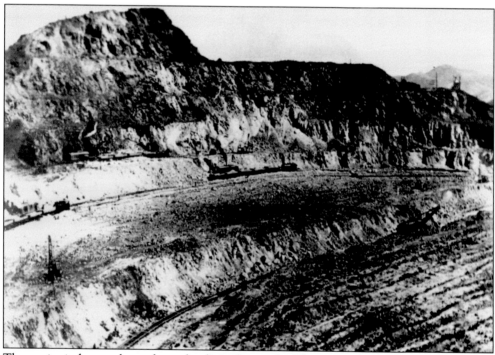

The main industry chugged on, leveling the earth. These are the train tracks and cars at Sacramento Pit, c. 1920—with a steam shovel working in the pit to load the train's cars. (Courtesy of Cochise County Historical Society.)

Six

EVOLVEMENT

In some respects, Bisbee changed little over those early decades. It grew, of course. It burned several times and was washed away just as often. The economy rebounded, again and again, from downturns in the price of copper. There was that dark day in Bisbee history called "The Deportation," but dark days are usually cleared with sunshine and fresh air. Bisbeeites were—and are—survivors. But after a few years, who knew of these tribulations? Not the newcomers, not the "just arrived," that's for sure. Not the ones who, early on, fell in love with the mile-high city.

So the city evolved while staying familiar. The downtown Victorian architecture remained, but subtle differences made themselves known throughout the city. Land that had once been hillsides became pits, some businesses thrived and grew, and some didn't. Communities were swallowed up. Phelps-Dodge would close the mines, causing the city great financial burdens, and Bisbee would become a place that, beginning in the late 1960s, was popular with hippie-types who wanted to "drop out for a while." And it would evolve into the tourist destination that it is today.

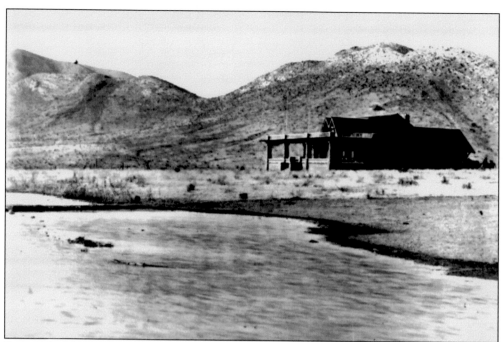

Seemingly out in the middle of nowhere, this was the new Bisbee Country Club, c. 1920.
(Courtesy of Cochise County Historical Society.)

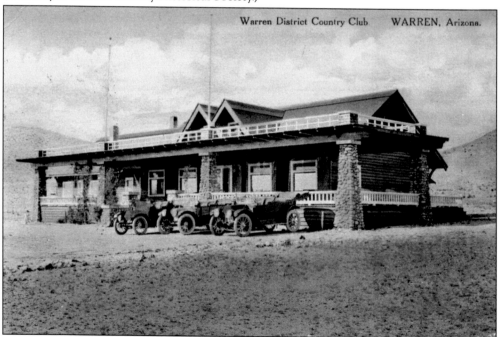

The Country Club was actually in what some considered to be the country, away from
metropolitan Bisbee (in Warren). Executives lived in that part of the Warren Mining District—
which actually encompassed all of Bisbee—and such a facility was deemed necessary. This
postcard was sent to Mr. Melvin Silk in Elroy, Wisconsin, when postage was 1¢—from which
came the term "penny postcard." (Courtesy of Bisbee Mining & Historical Museum.)

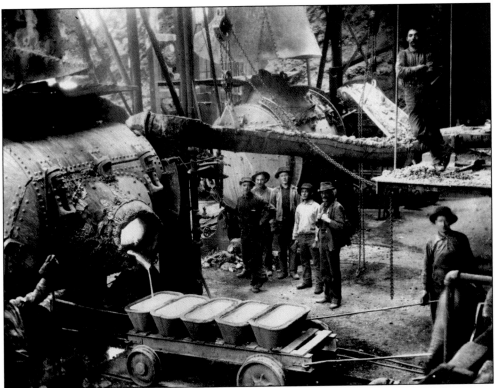

Yes, there was the "country club" crowd—and there were the hard-rock miners—and there were men (such as these) working day after day in the stiflingly hot smelters where novices found that it hurt to breathe! That's not soup, folks; it's molten metal being poured into huge ingots at the Copper Queen Smelter in Bisbee. (Courtesy of Bisbee Mining & Historical Museum.)

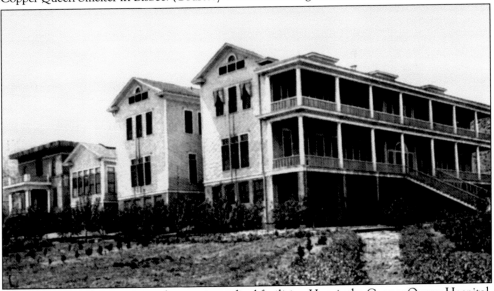

A changing population meant changes in medical facilities. Here is the Copper Queen Hospital, quite modern for its time, in Lowell, which was absorbed by Bisbee. (Courtesy of Cochise County Historical Society.)

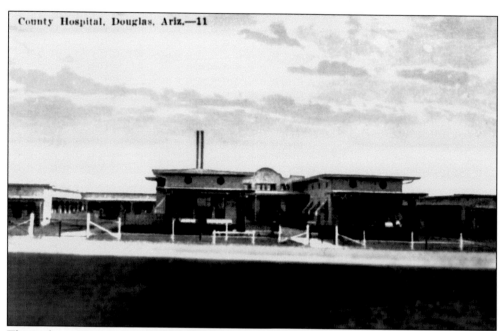

This is the original County Hospital, in Douglas, built on the same site as today's facility. It's said that many of the structures thereof are original. (Courtesy of Cochise County Historical Society.)

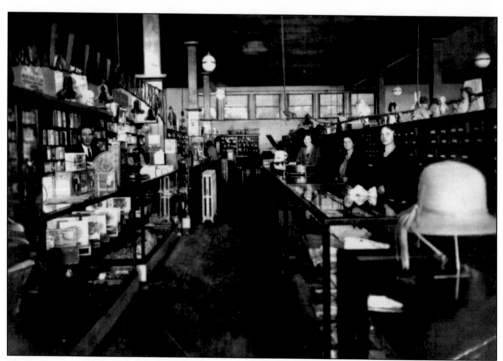

Phelps-Dodge did keep its own store for its employees and their families. This store, located in Lowell (which would be absorbed by Bisbee), c. 1925, shows that customers were still served by clerks behind the counter. Of the three women here, the one in the middle was step-mother to Ena Beezley Cain. The other two are unidentified. (Courtesy of Bisbee Restoration Museum.)

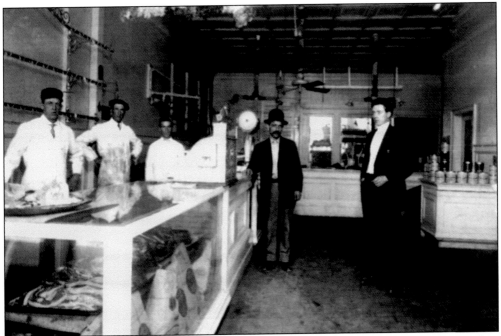

Meat markets were usually separate from grocery stores. This one, the Johnson Meat Market, was located just below the Elks Club. The man on the left is Matt Watlenburg; the others are unidentified. (Courtesy of Bisbee Restoration Museum.)

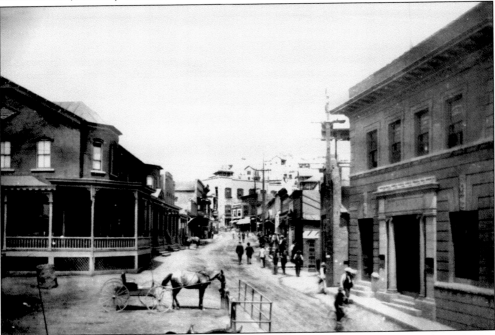

In this photo of early downtown, the building on the left was the library. It's now the two-story structure that's home to the post office (downstairs) and the library (upstairs). The building on the right was the Bank of Bisbee, before it became the Bank of America. (Courtesy of Bisbee Mining & Historical Museum.)

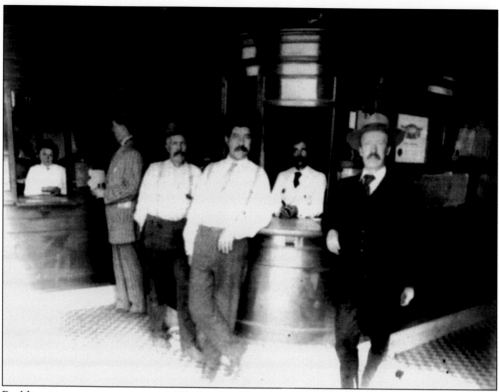

Building interiors were not as well lighted as they are now. This one shows the interior of the Bank of Bisbee. The people are unidentified. (Courtesy of Cochise County Historical Society.)

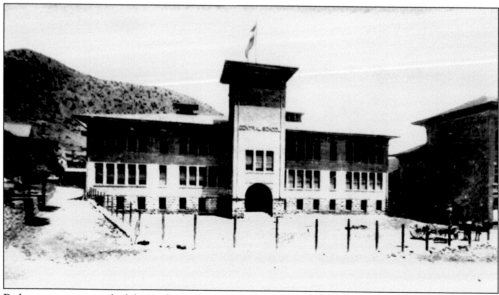

Bisbeeites were proud of their education system. This is the Central School when it was next-to-new. (Courtesy of Cochise County Historical Society.)

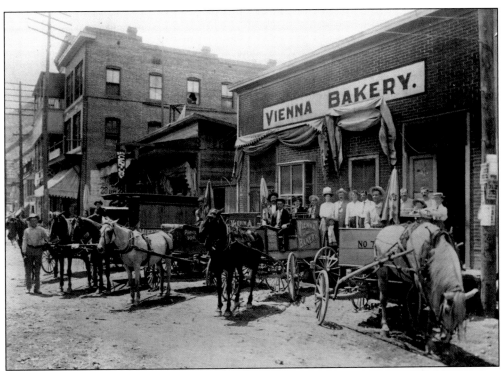

So much of Bisbee's history involves "overviews" because, by the very nature of its topography, one can see the city all at once. However, there is and was a real "downtown." This is Brewery Gulch, *c.* 1906; St. Elmo's is on the left. (Courtesy of Bisbee Mining & Historical Museum.)

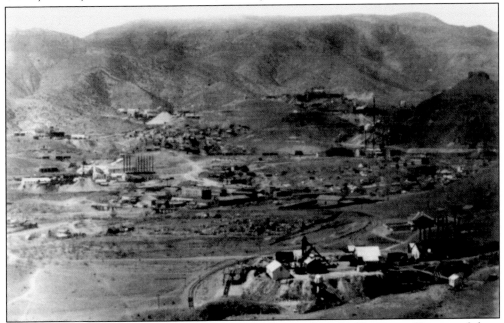

This is "Bonanza Circle" in Bisbee. Sacramento Hill is on the right, Evergreen Cemetery (where George Warren is buried) is in the center, and Shattuck-Denn Shaft is in the foreground. (Courtesy of Cochise County Historical Society.)

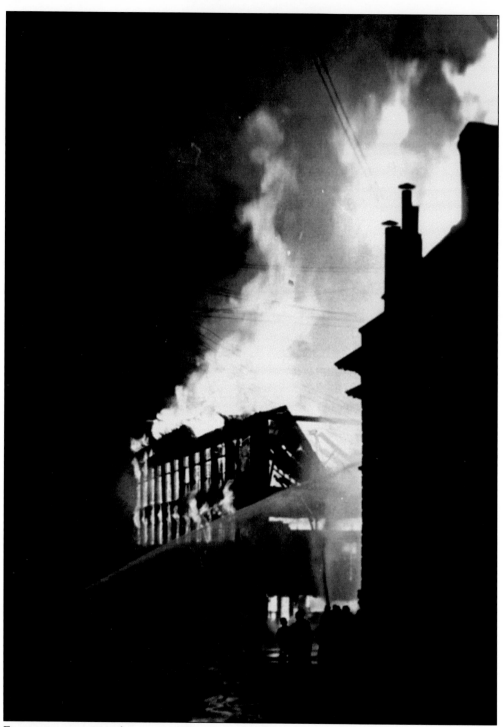

Fires were a constant threat, even after the new fire department was established. After the city struggled through the Great Depression, this fire destroyed the landmark Copper Queen Store one dark night in 1938. That's the Bank of Bisbee on the right. Talk about a town too tough to die! (Courtesy of Bisbee Mining & Historical Museum.)

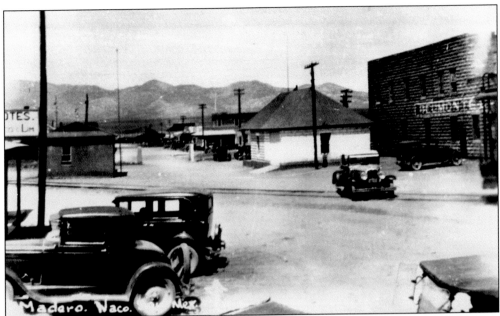

Not far from Bisbee is a true border town—part is in the United States, part is in Mexico. Naco (the name combines the last two letters of Arizona and the last two letters of Mexico) is actually closer to parts of the community called San Jose (which became part of Bisbee) than San Jose is to parts of downtown Bisbee. In 1932, the Great Depression was in full swing and not much commerce was going on, not in Bisbee or in nearby Naco. Madero Street in Naco is shown here. Naco is so near Bisbee that during the Mexican Revolution, Bisbeeites would pack a picnic and go sit atop boxcars and watch the battles, including when two American mercenaries, hired by opposing sides, took turns dropping bombs, and air currents or bad aim caused one to fall on the American side of the border. (Courtesy of Bisbee Mining & Historical Museum.)

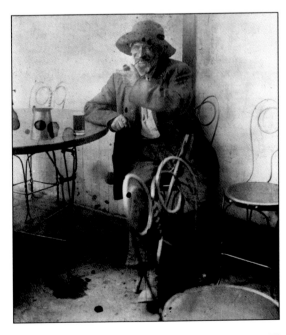

This is "The Rainmaker." No one ever knew his name or from whence he came. No one ever sent word for him but whenever a drought occurred, he'd appear in Bisbee from somewhere (Naco and points further south, maybe). He'd do his dance, perform his ritual, and the rains would come. Then, satisfied his work was done, he'd quench his thirst at a nearby watering hole before disappearing again—until the next time he knew, somehow, that he was needed. (Courtesy of Bisbee Mining & Historical Museum.)

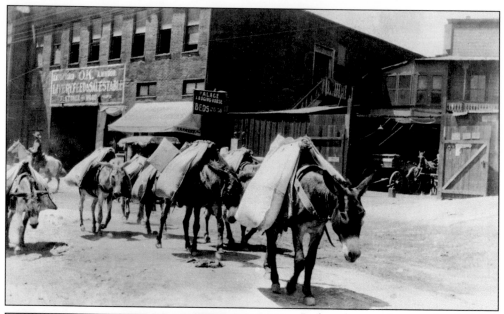

Pack mules were long used in Bisbee, even after automobiles became popular. This postcard features a photo by Mr. Irwin, and shows how the drayage was handled (see the horse and wagon in the barn in the background). (Courtesy of Bisbee Mining & Historical Museum.)

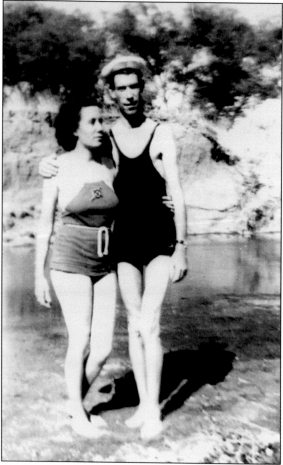

Amazingly, Bisbeeites found time to have some much-needed fun. Observe the haute couture of the bathing attire (worn by this unidentified man and woman). (Courtesy of Bisbee Mining & Historical Museum.)

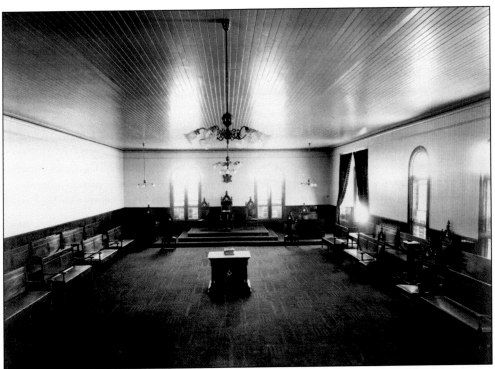

Masonry is centuries old, with lodges located worldwide. The orders of DeMolay, Eastern Star, Job's Daughters, and Rainbow for Girls are directly related. This is the interior of the Masonic Lodge as it first existed in Bisbee. According to Boyd Nichol, of the Bisbee Mining & Historical Museum, it was on the top floor of the building that now houses that facility. The lodge has, of course, moved elsewhere although it is quite active. (Courtesy of Bisbee Mining & Historical Museum.)

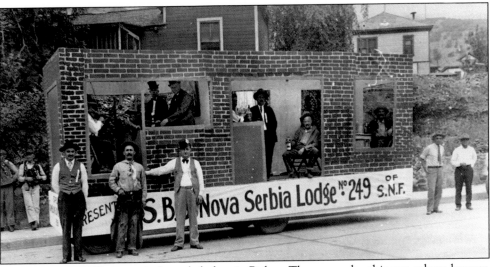

The Masons and Elks weren't the only lodges in Bisbee. There was also this one, whose banner, partially covered, labels them as Nova Serbia Lodge #249. The men are unidentified. (Courtesy of Bisbee Mining & Historical Museum.)

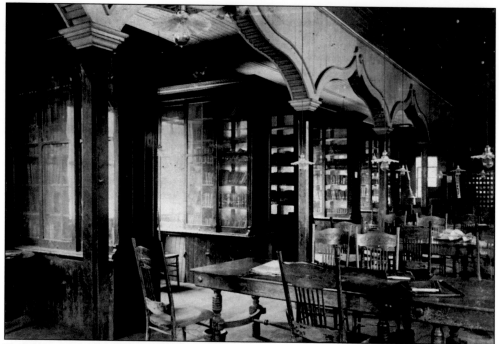

Yes, there undoubtedly was culture in the early days of Bisbee. This was the interior of the Copper Queen Library that was, accordin to Boyd Nichol, originally built as a mirror-image to the building housing today's museum. In some ways, it's regrettable that the original library was demolished in 1907; the good news, however, is that it was replaced with a facility that has become historically respected. (Courtesy of Bisbee Mining & Historical Museum.)

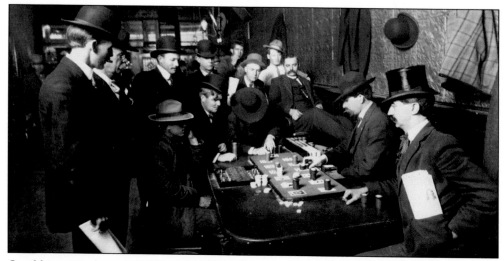

Quickly now—what game are these men playing? Not everyone immersed themselves in churches, schools, lodges, the library, etc. There were these "high rollers" who loved a game of chance in the Orient Saloon on Main Street. Note the different styles of hats they're wearing. Also of note is that they're all men—no women. In the early 20th century, "ladies" (according to the customs of the times) didn't frequent such establishments. There were "saloon girls," of course, but that—ahem!—is another story. (Courtesy of Bisbee Mining & Historical Museum.)

With time, some things in Bisbee would change (though never its essence). Business, styles of clothing, etc. Shown here in his service uniform is Fred Clouthier, who would go on to serve in 1965 as custodian of Cochise County Courthouse, long after it moved to Bisbee from Tombstone. He lived in the part of Bisbee called Warren. (Courtesy of Cochise County Historical Society.)

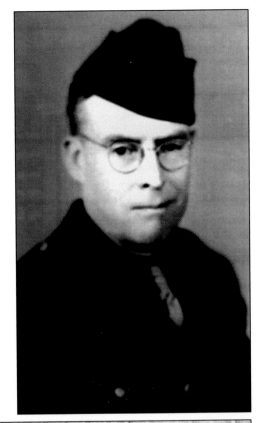

Confirming that Warren is, indeed, part of Bisbee is this post office. The words on its front window read, "United States Post Office, Warren Station, Bisbee, Arizona 85603." One could say that little has changed. (Photo by Ron Price.)

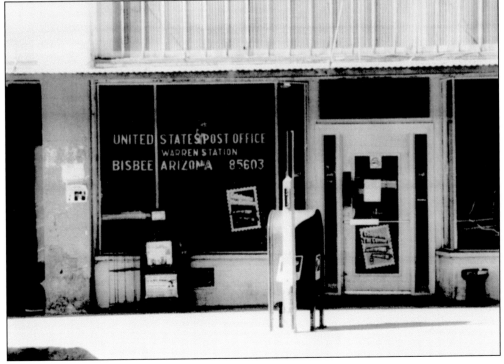

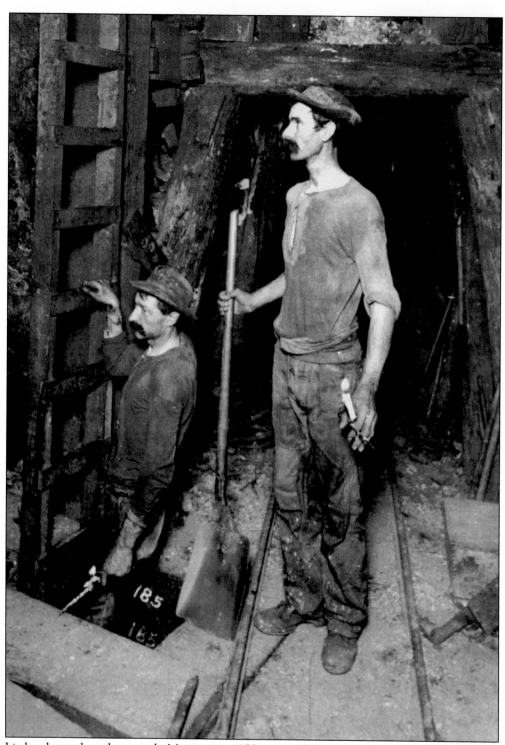

Little changed underground. Mining in 1975 was still hot, sweaty work. The men are unidentified, but their appearance is typical of their profession. (Courtesy of Bisbee Mining & Historical Museum.)

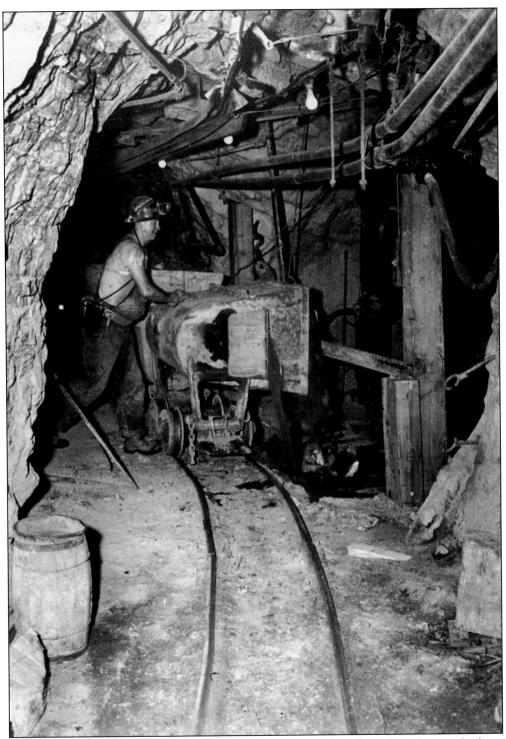

They dare not let themselves start thinking about the tons of earth, rock, and minerals above their heads. They were brave souls, these miners. This is inside the Campbell Shaft in 1975. The man is unidentified. (Courtesy of Bisbee Mining & Historical Museum.)

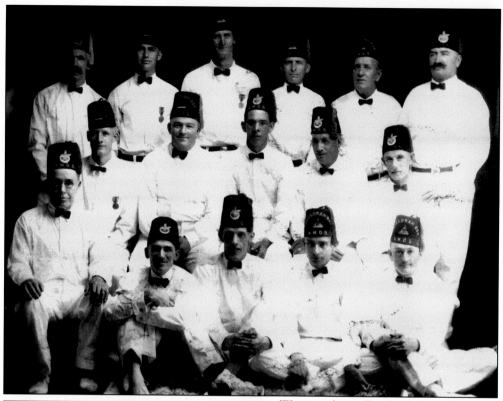

Wearing their official red fezzes,these unidentified Masons are also Shriners. It would have been a very special meeting. (Courtesy of Bisbee Restoration Museum.)

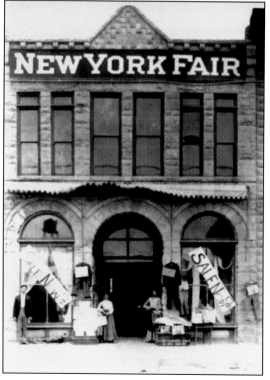

Bisbee evolved. This is the wonderful New York Fair Store, during the last days of its Going Out of Business Sale. The name "Fair Store" is still on the outside of the building in Tombstone Canyon—but it now houses the Bisbee Restoration Museum. (Courtesy of Cochise County Historical Society.)

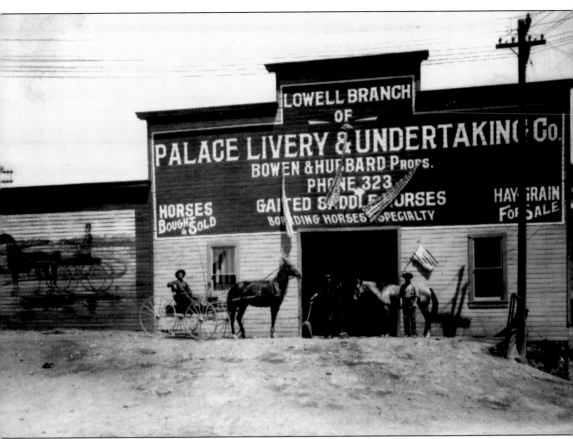

Yes, Bisbee evolved. From the days when telephones had three-digit numbers and Lowell, now part of Bisbee, had the Palace Livery & Undertaking Company, a rather interesting combination, one would think. (Courtesy of Bisbee Restoration Museum.)

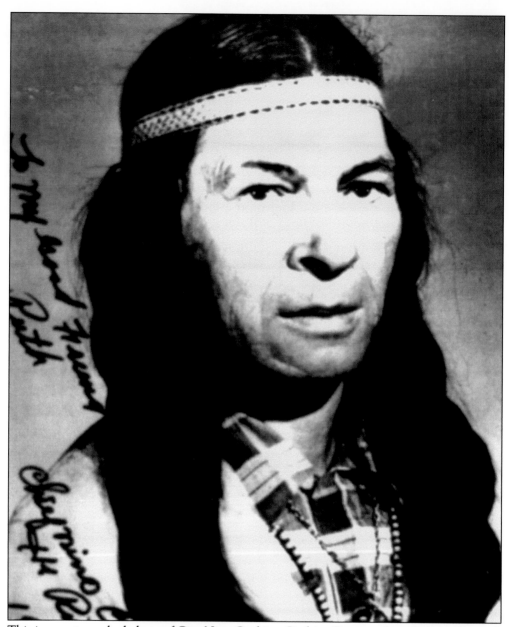

This is an autographed photo of Ciya Nino Cochise. Cochise County, where Bisbee is located, was named for this man's grandfather, who was a highly respected chief of the Chiricahua Apaches. Unfortunately, the chief was never photographed and all images of him are from an artist's viewpoint after his death. The Mule Mountains have guarded the area since the days when Cochise and his people ran free. Sue Thatcher, currently a resident of Sierra Vista, knew Ciya Nino Cochise personally, from the days when he frequented a restaurant in Bowie where she lived at the time. According to Thatcher, he was not fond of Geronimo, the warrior who'd earlier taken his nephew under his wing, teaching Naiche his version of the tactics of war. In their days at Bowie, Ciya Nino Cochise gladly autographed his own photograph and other materials, but would not affix his signature to anything that had to do with Geronimo. (Courtesy of Cochise County Historical Society.)

Seven

BISBEE TODAY

Bisbee is still a mile-high city where it's wise to take one's time getting acclimated, but the altitude is why Bisbee is cooler in the Arizona summer than lower desert metropolises. Altitude is also one reason that, contrary to popular opinion, saguaro cacti do not grow naturally in Bisbee. Saguaros are native to the Sonoran Desert, such as in Tucson, and have been transplanted to the high Chihuahuan Desert—where they don't belong.

That said, Bisbee is a definite experience. It's changed little and visitors downtown often feel they're in a time warp. Some streets are so narrow and so hilly, they've become one-way out of necessity, and small cars are preferred. It's also why there's no downtown mail delivery (merchants and residents go to the post-office to pick up their mail).

Prominent buildings are still the well-preserved Victorian style popular since the early 1900s. Brewery Gulch, Tombstone Canyon, and Main Street are still there, looking much as they did nearly 100 years ago. And there are three highways, some roads, and a lot of rocky paths into town. Let's begin by traveling Highway 80, the most-used of the highways and one that is sometimes called Bisbee's Front Door.

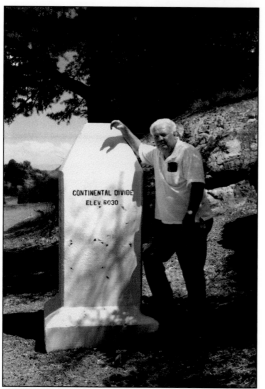

From the days of mule packs pulling ore wagons until 1958, the only way into Bisbee from the west meant going up and over Mule Mountain by way of Mule Pass. It was rugged, rocky, and dangerous. It also involved crossing what is said to be the Continental Divide. Today, this oft-visited marker stands atop the pass, at an altitude of 6,030 feet. The visitor asked not to be named. (From the author's collection.)

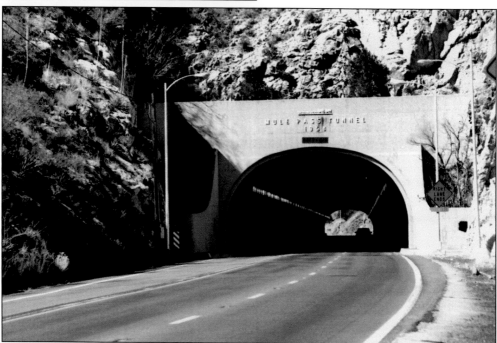

This tunnel, built in 1958, gives easier access to Bisbee. Instead of going up and over Mule Mountain, thereby crossing the Continental Divide, one can now go through the mountain! The Mule Pass Tunnel has, in fact, been called "The Gateway to Bisbee." (Photo by Ron Price.)

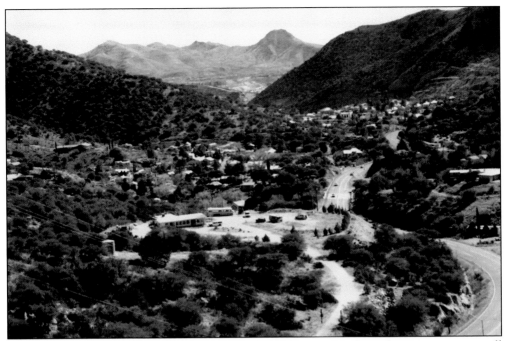

Choosing to go over the Pass brings one to a point where—as it's always been—one can see all of "old Bisbee" laid out below. (Photo by Ron Price.)

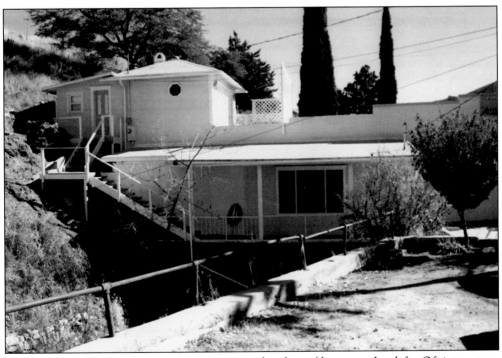

Further down Tombstone Canyon, one sees this home/shop on the left. Of interest to architectural or engineering students, it's an example of adapting. Built straddling the storm sewers, its design helps prevent the flood damage of earlier years. (Photo by Ron Price.)

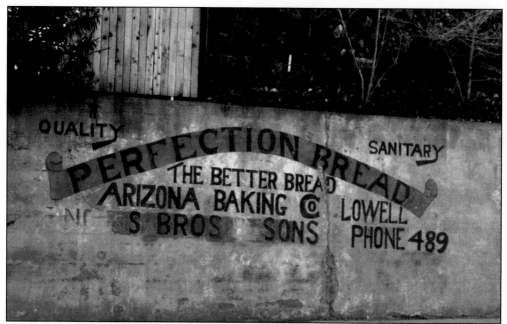

On a retainer wall described as being "across the street from Circle K," there's a faded sign from the Knoles Bakery (the three-digit phone number is a clue to the sign's age), which was owned and operated by a then-youthful Paul Knoles—who lived to be 97—and his father. There has been talk of restoring signs such as this one that pertain to Bisbee history. (Photo by Ron Price.)

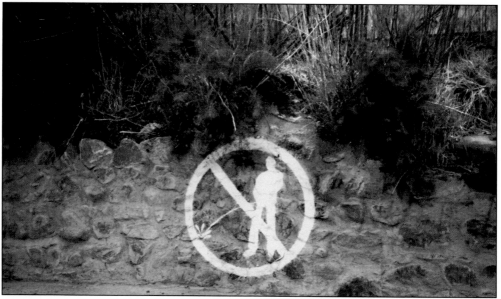

Another bit of Bisbee's "retainer-wall art" amuses passers-by just a few blocks up Brewery Gulch. That's the public sidewalk at the wall's base. The artwork is here because, in the past, some habitues of the city's watering holes (no pun intended) found it necessary, on the way home, to relieve themselves at this particular spot. Thus, this artwork was commissioned. It seems to work. (Photo by Ron Price.)

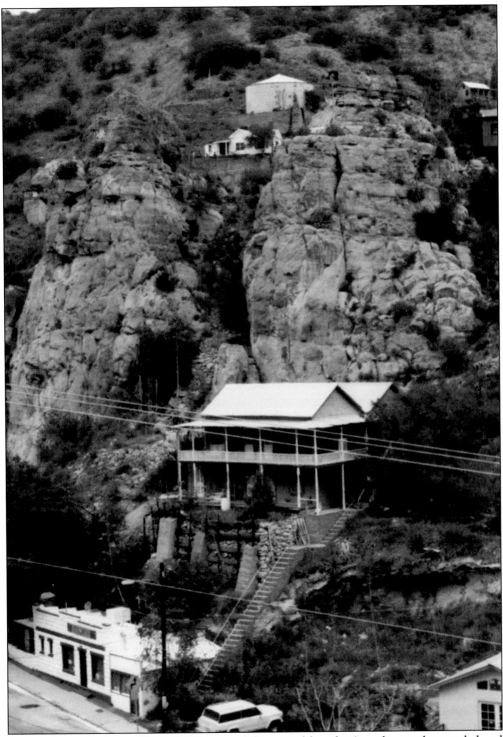

Today's Castle Rock is still a major feature of the city, although it's no longer the wooded and remote space that it was when George Warren built his cabin there. This photo was taken from the parking lot near the County Courthouse. (Photo by Ron Price.)

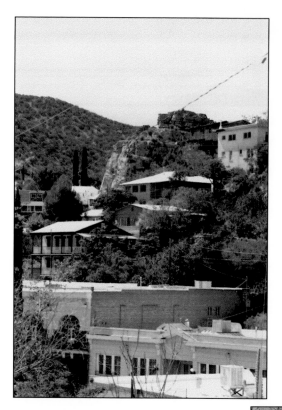

This is another view of Castle Rock. A steep, crooked, narrow street goes up and around behind it—and it's possible to find one's way to stand atop it. (Photo by Ron Price.)

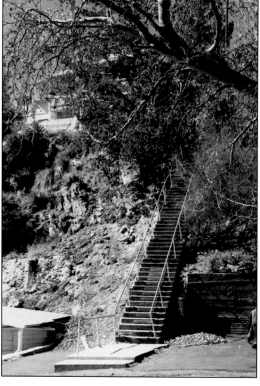

From a private parking lot at the base of Castle Rock, one can look across the street and see this prime example of the problems faced when building in the canyon. At the bottom is the home's parking space, and the stairs lead up to the residence. Imagine climbing these every time you arrive home. (Photo by Ron Price.)

Those steep stairs are not just a one-time thing. They're downtown and they'rehere, across the main street from the County Courthouse. These stairs beginin a narrow space between two businesses (one is a restaurant) and climb the canyon walls to where the home is built. (Photo by Ron Price.)

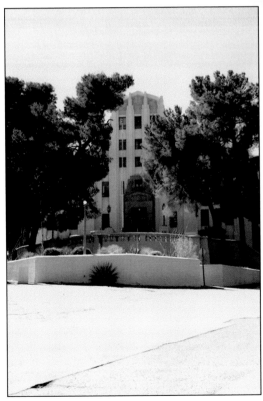

Facing Tombstone Canyon in Bisbee, this is the county courthouse for Cochise County. The facility—not the building—had previously been located in Tombstone. (Photo by Ron Price.)

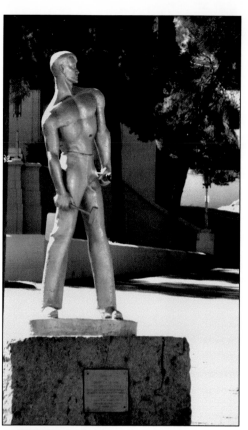

In front of the county courthouse, nearer the street, stands the Copper Man, a statue honoring the strong men who helped make Bisbee. (Photo by Ron Price.)

The copper plaque affixed to the Copper Man statue states that it is "Dedicated to Those Virile Men, the Copper Miners." and gives the date it was established as November 11, 1935. (Photo by Ron Price.)

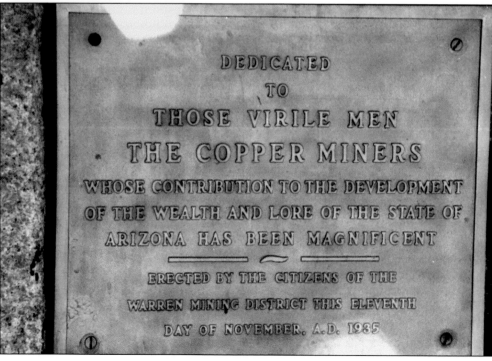

DEDICATED
TO
THOSE VIRILE MEN
THE COPPER MINERS
WHOSE CONTRIBUTION TO THE DEVELOPMENT
OF THE WEALTH AND LORE OF THE STATE OF
ARIZONA HAS BEEN MAGNIFICENT

ERECTED BY THE CITIZENS OF THE
WARREN MINING DISTRICT THIS ELEVENTH
DAY OF NOVEMBER, A.D. 1935

Old Bisbee hasn't changed much. Newcomers not yet accustomed to the altitude should still take their time in exploring—usually on foot—the hilly area generally described as being "behind the Copper Queen," where some of the more historic construction can be seen. (Photo by Ron Price.)

A short walk up Brewery Gulch, one can look to the right and see the 100-year-old Pythian Castle. (Photo by Ron Price.)

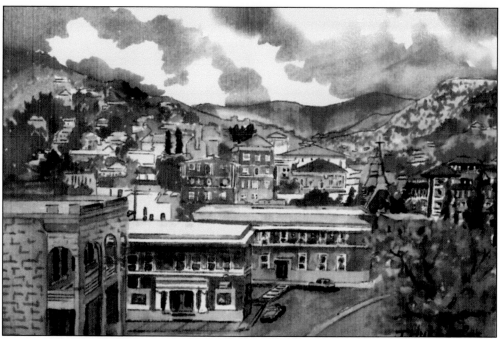

Bisbee is known for its artists, with what seems like dozens of galleries. This is one artist's rendition of what the Mule Mountains are guarding. The building on the lower left is the well-known multi-story library and post office flanked by the Bank of Bisbee, now the Bank of America. (Courtesy of artist Jan Huthoefer.)

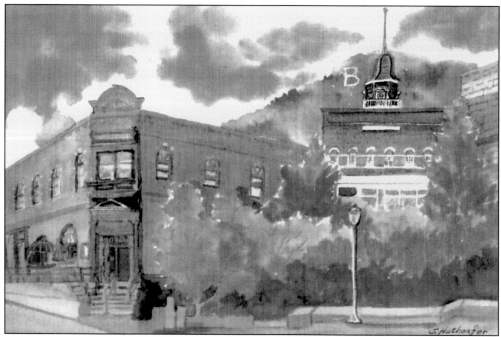

A major landmark, that's the old brewery building in Brewery Gulch. To the right, somewhat protected by shrubbery, is the Pythian Castle. (Courtesy of artist Jan Huthoefer.)

Once the Phelps-Dodge offices, this restored building became today's Bisbee Mining & Historical Museum, the most prominent of several museums in the city. (Photo by Ron Price.)

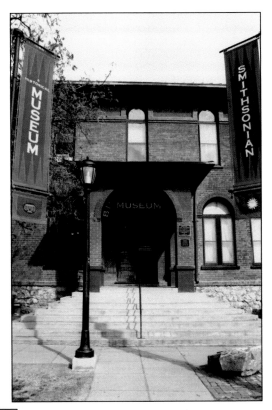

In front of the Bisbee Mining & Historical Museum, honoring Bisbee's copper mining heritage, are these restored examples of the equipment used in extracting the rich mineral from the earth. (Photo by Ron Price.)

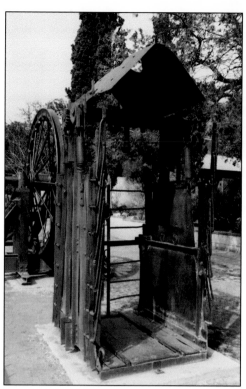

Here is one of the pieces of equipment from the Bisbee Mining & Historical Museum, restored. It's permanently fixed in front of the museum, close enough to walk up and touch. (Photo by Ron Price.)

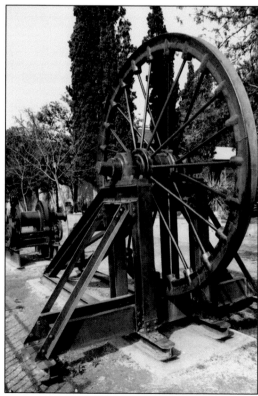

Mining machinery can be huge! In comparison, this is the wheel behind the piece featured in the photo above. (Photo by Ron Price.)

Continuing the journey along Highway 80, east-by-southeast from Old Bisbee, one sees on the right the old strip mines—first, Sacramento Pit (where once a mountain stood), followed by the Lavender Pit. Heavy equipment both dug and traveled these crooked paths down deep into the pits. (Photo by Ron Price.)

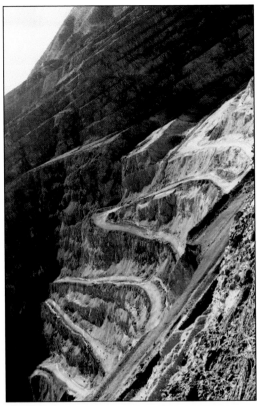

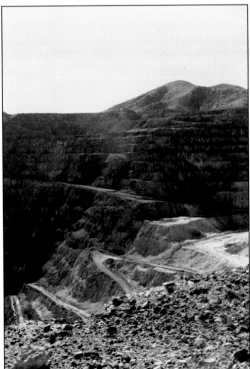

Standing at the edge of Lavender Pit, a visitor can see the layered colors of the mountain's heart. The colors have been exposed by a style of mining used because it was economical, but has since gone out of favor. (Photo by Ron Price.)

117

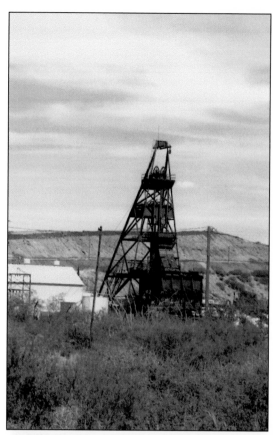

A little further along is the traffic circle called by the European term "roundabout." To one's right is part of Lowell. Turn right at the first exit and see the modern "yard" still owned by Phelps-Dodge. Nearby on the left is this monument to and relic of the industry. (Photo by Ron Price.)

Go further around the traffic circle and—no, it isn't a postcard. It's a funky billboard from the 1950s, restored because the "motel" (several Airstream trailers) is still there! (Photo by Ron Price.)

118

Dot's Diner at Shady Dell is in the Lowell section of Bisbee. The diner has appeared on TV and in magazines. A little further on the same road is Evergreen Cemetery, where George Warren is buried. A little known fact is that George is the man pictured on Arizona's State Seal. (Photo by Ron Price.)

Shady Dell and Dot's Diner aren't exactly "made up"—this is a taxi-cab parked in the lot between the diner and the Airstreams. It still runs and the owner will crank it up to drive downtown on business or to collect mail. (Photo by Ron Price.)

Turn right at the first exit, go past Phelps-Dodge, and see the land change. The San Jose section of Bisbee is a little less mountainous, without the ruggedness of the Mules. There may even be snow—yes, in southern Arizona, very close to the Mexican border. (Photo by Ron Price.)

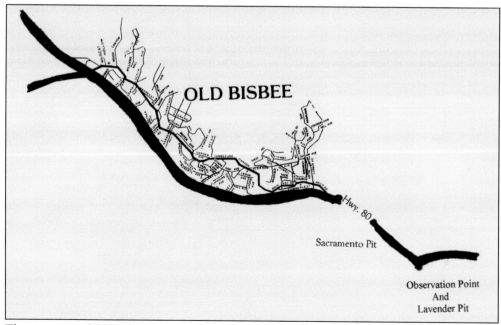

This is a map of Old Bisbee. Coming from the west (left) one has either gone over Mule Pass, across the Continental Divide or through the mountain on Highway 80. The latter, shown here, skims downtown on its way to the Copper Queen Mine, the Sacramento Pit, the Lavender Pit, etc. (Map drawn by Margaret "Maggie" Hartwell.)

The left of this map matches the right of the previous map. It's still Highway 80 but features the Warren Area, the part of Bisbee named for the controversial George Warren. (Map drawn by Margaret "Maggie" Hartwell.)

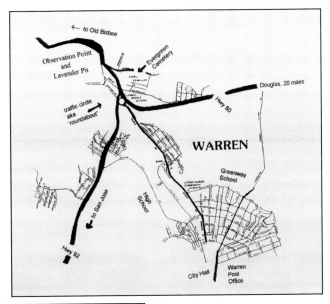

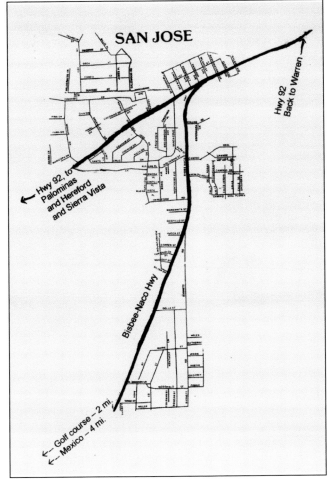

If continuing toward the third part of Bisbee (a.k.a. San Jose), one finds oneself on Highway 92 and heading into the afternoon sun. In San Jose, one may continue on Highway 92 to Sierra Vista or turn left onto the Bisbee-Naco Highway to Naco, the town that straddles the Arizona/Sonora border. (Map drawn by Margaret "Maggie" Hartwell.)

From the road leading out of Bisbee's "back door" (Highway 92, heading southwest out of San Jose), one can look south across the high desert and into Mexico. Much of the area is wide open spaces. It sometimes snows. (Photo by Ron Price.)

Beyond the Naco turn off, the landscape isn't especially impressive. However, just off the right side of the road is a jumble of rocky land that is, according to Nola Walker, the southernmost tip of the Rocky Mountains. (Photo by Ron Price.)

Looking south from that jumble of rocks is what appears to be a desert area full of brush. Just beyond that, shown here in the distance and visible from part of Bisbee, is the border town of Naco. Remember, the legend is that the name was invented by combining the last two letters of Arizona and the last two letters of Mexico (the town of Nacozari is another story). (Photo by Ron Price.)

Though tied to the copper mines in Bisbee through industry, the area is more attuned to raising cattle (which, in a circuitous way, is appropriate because the ranches were first established to feed—among others—the miners). It's often "open range"—meaning there are no fences—and often there are animals such as this walking along the highway. (Photo by Ron Price.)

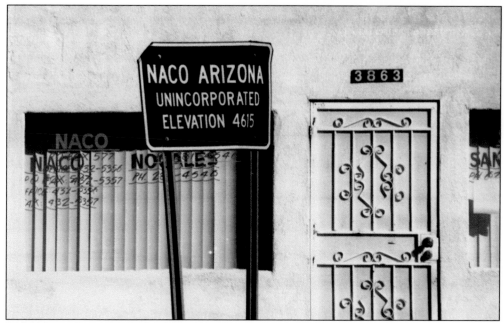

In San Jose, down the Bisbee-Naco Road, one soon comes to this sign. It's close enough that Bisbeeites once congregated there to observe an international incident as though it were staged for their entertainment. (Photo by Ron Price.)

This is the U.S. Border Station at Naco. (Photo by Ron Price.)

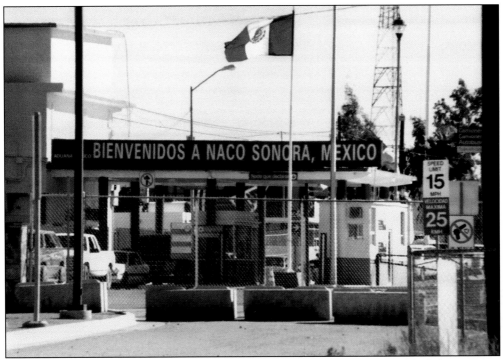

From this view, you're in the United States; step one foot on the other side of the concrete barriers and you're in Mexico. Look behind you and you can see San Jose, which is part of Bisbee. (Photo by Ron Price.)

This is the "back door" of Bisbee, where—regardless of the sparse homes and weeds along the road—is one point, on Highway 92, where the town begins. (Photo by Ron Price.)

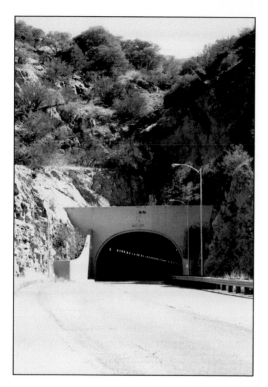

This is the other point where Bisbee begins—right back where we started our horseshoe shaped journey, at Mule Pass Tunnel, built in 1958. There is yet another entrance to the city, one that comes infrom the City of Douglas. It's well-traveled but not as well-traveled as these two. (Photo by Ron Price.)

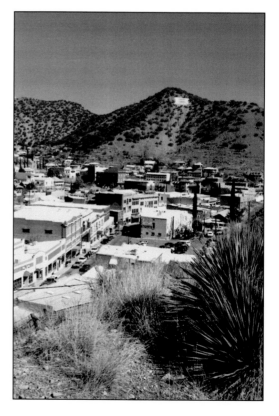

In between lies a city of parts. The downtown part is most famous and has been designated a historic district. Yet the whole city is a collection of villages built, moved, or absorbed—according to the industry's needs—and linked by roadways and politics. This is downtown, seen from a pullout along Highway 80 after going through the tunnel. Barring unusual disasters, it will be little changed even decades from now. (Photo by Ron Price.)

DISCOVER THOUSANDS OF LOCAL HISTORY BOOKS FEATURING MILLIONS OF VINTAGE IMAGES

Arcadia Publishing, the leading local history publisher in the United States, is committed to making history accessible and meaningful through publishing books that celebrate and preserve the heritage of America's people and places.

Find more books like this at
www.arcadiapublishing.com

Search for your hometown history, your old stomping grounds, and even your favorite sports team.